THE WOOD BEYOND THE WORLD By WILLIAM MORRIS

**

Facsimile of the Kelmscott Press Edition (1894)

DOVER PUBLICATIONS, INC. NEW YORK Published in Canada by General Publishing Company, Ltd., 30 Lesmill Road, Don Mills, Toronto, Ontario.

Published in the United Kingdom by Constable and Company, Ltd., 10 Orange Street, London WC 2.

This Dover edition, first published in 1972, is an unabridged facsimile of the work originally published by the Kelmscott Press, Hammersmith, England, in 1894.

International Standard Book Number: 0-486-22791-X Library of Congress Catalog Card Number: 71-189346

Manufactured in the United States of America Dover Publications, Inc. 180 Varick Street New York, N.Y. 10014

THE MOOD BEYOND THE MORLD. BY MILLIAM MORRIS.

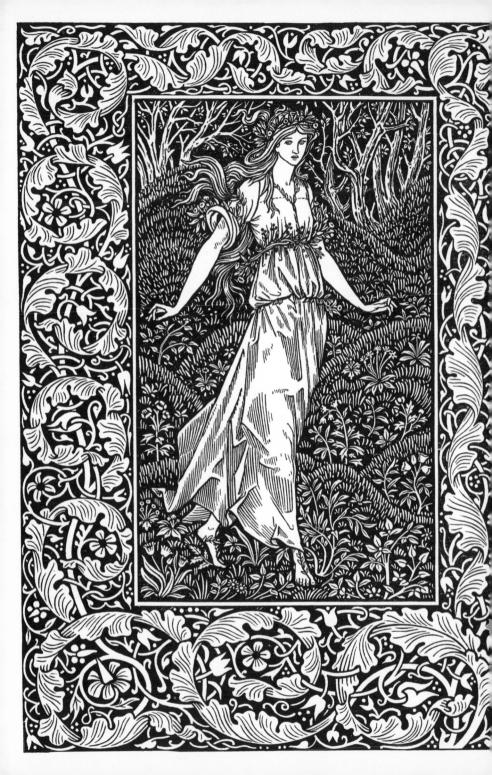

The MOODBEYOND The MORLD Chapter I. Of Golden Malter and his father 森蓉

ABILE AGO CHERE MAS AYOUNGMAN DMELLINGIN AGREATAND goodly city by theseawhich bad toname Langton on Bolm. Be was but of five and

twenty winters, a fair/faced man, yellow/baired, tall and strong; rather wiser than foolisher than young men are mostly wont; a valiant youth, & a kind; not of many words but courteous of speech; noroisterer, nought masterful, but peaceable and knowing how to for/ bear: in a fray a perilous foe, & a trusty war/fellow. Dis father, with whom he was dwelling when this tale begins, was a great merchant, richer than a baron of the land, a head/man of the greatest of the Lineages of Langton, and a captain of the Dorte; he was of the Lineage of the Goldings, therefore was he called Of the wife of Golden Walter

Bartholomew Golden. & his son Gold, en Walter @Now vemay well deem that such a voungling as this was looked upon by all as a lucky man without a lack : but there was this flaw in his lot. whereas he had fallen into the toils of love of a woman exceeding fair, and had taken her to wife. she nought un willing as it seemed. But when they had been wedded some six months he found by manifest tokens, that his fairness was not so much to her but that she must seek to the foulness of one worser than be in all ways; wherefore his rest departed from him, whereas he bated her for her untruth and her batred of him: vet would the sound of her voice. as she came & went in the house, make his heart beat; and the sight of her stirred desire within him, so that he longed for her to be sweet and kind with him. and deemed that, might it be so, he should forget all the evil gone by. But it was not so; for ever when she saw him, her face changed, and her hatred of him became manifest, and howsoever she were sweet with others, with

him she was hard and sour.

wea the very streets of the city, became loathsome to him; and yet he called to mind that the world was wide and bebut a voung man. Soon a davas he sat with his father alone, he spake to him and said: father. I was on the guays even now, and I looked on the ships that were nigh boun. & thy sign I saw on a tall ship that seemed to me nighest boun. Mill it be long ere she sail? Way, said his father, that ship. which hight the Katherine. will they warpout of the haven in two davs' time. But why askest thou of her? @ The shortest word is best. father. said Mal ter. and this it is. that I would depart in the said ship & see other lands . Vea and whither, son? said the merchant, 12 Mhither she goeth, said Malter. for I am ill at ease at home, as thou wottest, father. @The merchant held his peace awhile, and looked hard on his son. for there was strong love between them: but at last he said : Mell son, maybe it 3 b2

chambers of his father's house,

Of father O this went on a while till the and son

Malter is were best for thee: but maybe also we to depart shall not meet again J Vet if we do meet, father, then shalt thou see a new man in me. @ Mell, said Bartholomew. at least I know on whom to lav the loss of thee. and when thou art gone, for thou shalt have thine own way herein. she shall no longer abide in my house. Nav. but it were for the strife that should arise thenceforth betwixt her kindred and ours. it should go somewhat worse with her than that, & Said Malter: I pray thee shame ber not more than needs must be lest. so doing thou shame both me and thyself also. Bartholomew held his peace again for a while: then he said: Goeth she with child, my son? I Malter reddened. and said: I wot not: nor of whom the child may be. Then they both sat silent, till Bartholomew spake, saying: The end of it is, son, that this is Monday, and that thou shalt go aboard in the small hours of Mednesday: and meanwhile I shall look to it that thou go not away empty/handed: the skipperof the Katherine is a good man and

true, and knows the seas well: and my servant Robert the Low, who is clerk of the lading, is trustworthy and wise. and as myself in all matters that look towards chaffer. The Katherine is new and stout/builded. & should be lucky. whereas she is under the ward of her who is the saint called upon in the church where thou wert christened.and myself before thee: & thymother. and my father and mother all lie under the chancel thereof, as thou wottest. Therewith the elder rose up and went his ways about his business, and there was no more said betwixt him and his son on this matter.

Chapter II. Golden Malter takes ship to sail the seas A A

DEN Malter went down to the Katherine next morning, there was the skipper Geoffrey, who did him reverence, and made him all cheer, and

showed him his room aboard ship, and the plenteous goods which his father had sent down to the quays already, Of the ship Katherine

the quav

Malter on such haste as he had made. Malter thanked his father's love in his heart. but otherwise took little heed to his af fairs, but wore away the time about the haven, gazing listlessly on the ships that were making them ready outward, or unlading. & the mariners and aliens coming and going: and all these were to him as the curious images woven on a tapestry. #Ht last when he had well nigh come back again to the Katherine. he saw there a tall ship, which he had scarce noted before, a ship all/boun, which had her boats out, and men sitting to the oars thereof ready to tow her outwards when the hawser should be cast off. and by seeming her mariners were but abiding for some one or other to come aboard.

O Malter stood idly watching the said ship, and as he looked, lo1 folk passing him toward the gangway. These were three: first came a dwarf, dark/brown of hue & hideous, with long arms & ears exceeding great and dogrteeth that stuck out like the fangs of a wild beast. De was clad in a 6

rich coat of yellow silk, and bare in his Of those hand a crooked bow, and was girt with Three a broad sax.

BFTER him came a maiden, young by seeming, of scarce twenty summers; fair of face as a flower; grev/eyed, brown/haired. with lips full & red, slim and gentle of body. Simple was her array, of a short and strait green gown, so that on her right ankle was clear to see an iron ring. HST of the three was a lady, atall and stately, so radiant of visage & glorious of raiment. that it were hard to say what like she was: for scarce might the eye gaze steady upon her exceeding beauty: vet must every son of Adam who found himselfanigh her, lift up his eves again after he had dropped them, and look again on her, and yet again & vet again. Even so did Malter, and as the three passed by him, it seemed to him as if all the other folk there about had vanished and were nought: nor had heany vision before his eves of any looking on them. save himself alone. They went

The ship departs

over the gangway into the ship, and he strange saw them go along the deck till they came to the house on the poop, and en, tered it, and were gone from his sight E There he stood staring, till little by little the thronging people of the quavs came into his evershot again: then he saw how the hawser was cast

off and the boats fell to tugging the big ship toward the harbour mouth with hale and how of men. Then the sail fell down from the vard and was sheeted home and filled with the fair wind as the ship's bows ran up on the first green wave outside the haven. Even therewith the shipmen cast abroad a banner, whereon was done in a green field a grim wolf ramping up against a maiden, and so went the ship upon her way.

HLTER stood awhile staring at her empty place where the waves ran into the haven mouth, and then turned aside and toward the Katherine : and at first he was minded to go ask shipmaster Geoffrev of what he knew concerning the 8

said ship and her alien way/farers; but Those then it came into his mind. that all this Three was but an imagination or dream of the again day. & that he were best to leave it untold to any. So therewith he went his way from the water/side, and through thestreets unto his father's house: but when he was but a little way thence, and the door was before him. him/seemed for a moment of time that he beheld those three coming out down the steps of stone and into the street: to wit the dwarf.themaiden.andthestatelylady: but when he stood still to abide their coming, and looked toward them, lot there was nothing before him save the goodly house of Bartholomew Golden. and three children & a cur dog plaving about the steps thereof. & about him were four or five passers, by going about their business. Then was he all confused in his mind. & knew not what to make of it. whether those whom he had seemed to see pass aboard ship were but images of a dream, or children of Hdam in very flesh.

The images abidewith him

OMSOEVER. he entered the house, and found his father in the chamber, and fell to speech with him about their matters: but for all that he loved his father, & worshipped him as a wise & valiant man, yet at that hour he might not hearken the words of his mouth. so much was his mind en, tangled in the thought of those three, and they were ever before his eyes, as if they had been painted on a table by the best of limners. And of the two women he thought exceeding much, & cast no wyte upon himself for running after the desire of strange women. for he said to himself that he desired not either of the twain; nay, he might not tell which of the twain. the maiden or the stately queen, were clearest to his eves: but sore he desired to see both of them again. & to know what they were. O wore the hours till the Mednes, a day morning, and it was time that be should bid farewell to his father & get aboard ship; but his father led him down to the guays and on to the Katherine, and there Malter embraced

him, not without tears & forebodings; for his heart was full. Then presently the old man went aland; the gangway was unshipped, the hawsers cast off; the oars of the towing boats splashed in the dark water, the sail fell down from the yard, and was sheeted home, & out plunged the Katherine into the misty sea and rolled up the grey slopes, cast, ing abroad her ancient withal, whereon was beaten the token of Bartholomew Golden, to wit a B and a G to the right and the left, & thereabove a cross and a triangle rising from the midst.

HLTER stood on the stern and beheld, yet more with the mind of him than with his eyes; for it all seemed but the double of what the other ship had done; and he thought of it as if the twain were as beads strung on one string & led away by it into the same place, and thence to go in the like order, & so on again and again, and never to draw nigher to each other.

Malter saíls away

Chapter III. Malter heareth tidings of the death of his father 2 2

AST sailed the Katherine over the seas, & nought befell to tell of, either to herself or her crew. She came to one cheapingtown & then to another.

and so on to a third and a fourth: & at each was buying and selling after the manner of chapmen; & Malter not only looked on the doings of his father's folk, butlenta hand, what he might, to help them in all matters, whether it were in seaman's craft, or in chaffer. And the further he went and the longer the time wore. the more he was eased of his old trouble wherein his wife & her treas son had to do , But as for the other trouble, to wit his desire & longing to come up with those three, it yet flicker, ed before him; and though he had not seen them again as one sees people in the streets, and as if he might touch them if he would. vet were their images often before his mind's eye; and vet.as time wore. not so often. nor so troubl-12

ously: & forsooth both to those about The last bim and to himself. he seemed as a man of the cheaping, well bealed of his melancholy mood. steads OUT they left that fourth stead.& sailed over the seas, and came to a fifth, a very great and fair city, which they had made more than seven months from Langton on Bolm; and by this time was Malter taking heed & jovance in such things as were toward in that fair city, so far from his kindred, & especially he looked on the fair women there. & desired them. & loved them: but lightly, as befalleth young men @ Now this was the last country whereto the Katherine was boun: so there they abode some ten months in daily chaffer, and in pleasuring them in beholding all that there was of rare and goodly, & making merry with the merchants and the towns, folk, and the country, folk beyond the gates, and Walter was grown as busy and gay as a strong young man is like to be. & was as one who would fain be of some account amongst his own folk. But at the end of this while, it befel on a day.

A messenger of evil as he was leaving his hostel for his booth in the market, & had the door in his hand, there stood before him three mariners in the guise of his own country, and with them was one of clerkly aspect, whom he knew at once for his father's scrivener, Hrnold Penstrong by name; and when Walter saw him his heart failed him and he cried out: Hrnold, what tidings? Is all well with the folk at Langton? Said Hrnold: Evil tidings are come with me; matters are ill with thy folk; for I may not hide that thy father, Bartholomew Golden, is dead, God rest his soul.

T that word it was to Walter as if all that trouble which but now had sat so light upon him, was once again fresh and heavy, & that his past life of the last few months had never been; and it was to him as if he saw his father lying dead on his bed, and heard the folk lamenting about the house. Be held his peace a while, and then he said in a voice as of an angry man: What Hrnold 1 and did he die in his bed, or how? for he was neither old

H tale of nor ailing when we parted B Said Hrnold: Vea. in his bed he died: but first strife hewas somewhat sword bitten @Vea. & how? quoth Malter @ Said Hrnold: Then thou wert gone, in a few days' wearing, thy father sent thy wife out of his house back to her kindred of the Reddings with no honour, and vet with no such shame as might have been.without blame to us of those who knew the tale of thee and her: which, Godrarmercy, will be pretty much the whole of the city @ Nevertheless, the Reddings took it amiss, & would have a mote with us Goldings to talk of booting. By ill/luck we yearsaid that for the saving of the city's peace. But what betid? Me met in our Gild/hall.& there befell the talk between us: and in that talk certain words could not be hid, den, though they were none too seemly nor too meek. And the said words once spoken drew forth the whetted steel: & there then was the hewing & thrust, ing 1 Two of ours were slain outright on the floor, and four of theirs, & many were hurt on either side. Of these was 15

A bidding thy father, for as thou may st well deem, to return he was nought backward in the fray;

be was nought backward in the fray; but despite his hurts, two in the side and one on the arm, he went home on his own feet, & we deemed that we had come to our above. But well/a/way1 it was an evil victory, whereas in ten days hedied of his hurts. God have his soulf But now my master, thou mayst well wot that I am not come to tell thee this only, but moreover to bear the word of the kindred, to wit that thou come back with me straightway in the swift cutter which hath borne me & the tidings; and thou mayst look to it, that though she be swift and light, she is a keel full weatherly.

DEN said Walter: This is a bid ding of war. Come back will I, and the Reddings shall wot of my coming. Hre ye all/boun? If Yea, said Hrnold, we may up anchor this very day, or to/morrow morn at latest. But what aileth thee, master, that thou starest so wild over my shoulder? I pray thee take it not so much to heart Ever it is the wont of fathers to de-16

part this world before their sons. **here** come BUT Malter's visage from wrath, the Three ful red had become pale, and he again pointed up street, and cried out: Look | dost thou see? I See what. master? quoth Hrnold: @ What 1 here cometh an ape in gay raiment: belike the beast of some jongleur. Nay, by God's wounds 1'tis a man, though he be exceeding missshapen likeaverv der vil. Vea and now there cometh a pretty maid going as if she were of his menev: and lot here, a most goodly and noble lady 1 Vea. I see: & doubtless sheowneth both the two, and is of the greatest of the folk of this fair city: for on the maiden's ankle Isawan iron ring, which betokeneth thralldom amongst these aliens. But this is strangel for notest thou not how the folk in the street heed not this quaint show; nay not even the stately lady, though she be as lovely as a goddess of the gentiles, and beareth on her gems that would buy Langton twice over: surely they must be overwont to strange and gallant sights. Butnow, master, butnow / DYea, what

C

They are gone suddenly

is it? said Malter, WMhy, master, they should not vet begone out of every shot. vet gone they are a Tabat is become of them, are they sunk into the earth? Tush, man! said Malter, looking not on Arnold, but still staring down the street: they have gone into some house while thine eves were turned from them a moment J Nay master, nay, said Hrnold, mine eves were not off them one instant of time. Mell. said Malter. somewhat snappishly, they are gone now, and what have we to do to heed such toys, we with all this grief and strife on our hands? Now would I be alone to turn the matter of thine errand over in my mind B Meantime do thou tell the shipmaster Geoffrey and our other folk of these tidings, and thereafter get thee all ready; and come hither to me before sunrise to morrow. and I shall be ready for my part; & so sail we back to Langton.

berealton beturned him back into the house, & the others went their ways; but Malter sat alone in his chamber a long while, and pon-

dered these things in his mind. And Malter whiles he made up his mind that he ponderwould think no more of the vision of eth the those three, but would fare back to matter Langton, and enter into the strife with the Reddings & quell them, or die else. But lo, when he was quite steady in this doom. & his heart was lightened thereby, he found that he thought no more of the Reddings and their strife. but as matters that were passed and done with, & that now he was thinking and devising if by any means hemight find out in what land dwelt those three. And then again he strove to put that from him.saving that what he had seen was but meet for one brainsick, and adreamer of dreams. But furthermore he thought, Yea. and was Arnold. who this last time had seen the images of those three, a dreamer of waking dreams? for he was nought wonted in such wise; then thought he: Ht least I am well content that he spake to me of their likeness. not I to him: for so I may tell that there was at least some thing before my eyes which grew not

c 2

out of mine own brain. And yet again, why should I follow them; and what should I get by it; & indeed how shall I set about it?

has be turned the matter over and over; & at last seeing that if he grew no foolisher over it, he grewno wiser, be became weary thereof, and bestirred him, & saw to the trussing up of his goods, & made all ready for his departure, and so wore the day and slept at nightfall; and at daybreak comes Hrnold to lead him to their keel, which hight the Bartholomew. De tarried nought, & with few farewells went aboard ship, & an hour after they were in the open sea with the ship's head turned toward Langton on Dolm.

Chapter IV. Storm befalls the Barthon lomew, & she is driven off her course it

> OM swift sailed the Bartholomew for four weeks toward the north/west with a fair wind, and all was well with ship and crew. Then the wind died

out on even of a day, so that the ship

dered these things in his mind. And Malter whiles he made up his mind that he ponderwould think no more of the vision of eth the those three, but would fare back to matter Langton, and enter into the strife with the Reddings & quell them. or die else. But lo. when he was quite steady in this doom, & his heart was lightened thereby, he found that he thought no more of the Reddings and their strife. but as matters that were passed and done with. & that now he was thinking and devising if by any means hemight find out in what land dwelt those three. And then again he strove to put that from him.saving that what he had seen was but meet for one brainsick, and adreamer of dreams. But furthermore he thought, Yea, and was Arnold, who this last time had seen the images of those three, a dreamer of waking dreams? for he was nought wonted in such wise: then thought he: Ht least I am well content that he spake to me of their likeness, not I to him; for so I may tell that there was at least somer thing before my eyes which grew not

C2

out of mine own brain. And yet again, why should I follow them; and what should I get by it; & indeed how shall I set about it?

bas he turned the matter over and over; & at last seeing that if he grew no foolisher over it, he grewno wiser, he became weary thereof, and bestirred him, & saw to the trussing up of his goods, & made all ready for his departure, and so wore the day and slept at nightfall; and at daybreak comes Hrnold to lead him to their keel, which hight the Bartholomew. Be tarried nought, & with few farewells went aboard ship, & an hour after they were in the open sea with the ship's head turned toward Langton on Bolm.

Chapter IV. Storm befalls the Barthon lomew, & she is driven off her course 2

> OM swift sailed the Bartholomew for four weeks toward the north/west with a fair wind, and all was well with ship and crew. Then the wind died

out on even of a day, so that the ship

scarcemade way at all, though sherolly H calm ed in a great swell of the sea, so great, that it seemed to ridge all the main athwart. Moreoverdown in the west was a great bank of cloud huddled up in haze, whereas for twenty days past the sky had been clear, save for a few bright white clouds flying before the wind. Now the shipmaster. a man right cunning in his craft. looked long on sea & sky, and then turned and bade themariners take in sailand beright heedful. And when Malter asked him what he looked for. & wherefore he spake not to him thereof, he said surlily: Thy should I tell thee what any fool can see without telling, to wit that there is weather to hand? E So they abode what should befall, and Malter went to his room to sleep away the uneasy while, for the night was now fallen: & he knew no more till he was waked up by great hubbub and clamour of the shipmen, and the whipping of ropes. and thunder of flapping sails, and the tossing & weltering of the ship withal. But. being a very stout/hearted young

man, he lay still in his room. partly be-H gale cause he was a landsman. and had no mind to tumble about amongst the shipmen and hinder them: and withal he said to himself: What matter whether I go down to the bottom of the sea, or come back to Langton, since either way my life or my death will take away from me the fulfilment of desire? Vet soothly if there hath been a shift of wind. that is not soill: for then shall we be driven to other lands, and so at the least our home coming shall be der laved. & other tidings may hap amidst of our tarrving. So let all be as it will Bo in a little while, in spite of the ship's wallowing & the tumult of the wind and waves, he fell asleep again, and woke no more till it was full daylight, and there was the shipmaster standing in the door of his room, the sea/water all streaming from his wet/ weather raiment. he said to Malter: Voung master, the sele of the day to theel for by good hap we have gotten into another day. Now I shall tell thee that we have striven to beat. so as not 22

to be driven of four course, but all would H foul not avail, wherefore for these three wind hours we have been running before the wind: but. fair sir. so big hath been the sea that but for our ship being of the stoutest, and our men all yare, we had all grown exceeding wise concerning the ground of the mid/main. Draise be to St. Nicholas and all hallows! for though ye shall presently look upon a newsea, and maybea new land to boot. vet is that better than looking on the ugly things down below B Is all well with ship and crew then? said Walter Weaforsooth, said the shipmaster; verily the Bartholomew is the darling of Oak Moods: come up and look at it, how she is dealing with wind and waves all free from fear.

O Malter did on his foul weather raiment, and went up on to the guarter/deck, and there indeed was a change of days: for the sea was dark & tumbling mountain , high, and the white/horses were running down the valleys thereof, & the clouds drave

low over all, and bore a scud of rain

towards Langton

The stern along with them; and though there was but a rag of sail on her, the ship flew before the wind, rolling a great wash of water from bulwark to bulwark. Balal ter stood looking on it all awhile, hold, ing on by a stay, rope, and saving to himself that it was well that they were driving so fast toward new things.

DEN the shipmaster came up to him and clapped him on the shoulder and said: Mell, ship,

mate, cheer up1 and now come below again and eat some meat, and drink a cup with me J So Malter went down and ate and drank, and his heart was lighter than it had been since he had heard of his father's death. & the feud awaiting him at home, which forsooth he had deemed would stay his wander, ings a weary while, and therewithal his hopes.Butnowitseemedasifheneeds must wander, would he, would he not: & soit was that even this fed his hope: so sore his heart clung to that desire of his to seek home to those three that seemed to call him unto them.

Chapter V. Now t

0

 \mathcal{V} . Now they come to a new

BREE days they drave before the wind, & on the fourth the clouds lifted, the sun shone out & the offing was clear; the wind bad much abated, though

it still blew a breeze, & was a head wind for sailing toward the country of Lang, ton. So then the master said that, since they were bewildered, and the wind so ill to deal with, it were best to go still before the wind that they might make some land and get knowledge of their whereabouts from the folk thereof. Alithal he said that he deemed the land not to be very far distant.

O did they, and sailed on pleas, antly enough, for the weather kept on mending, and the wind fell till it was but a light breeze, yet still foul for Langton.

O wore three days, and on the eve of the third, the man from the topmast cried out that he saw landahead; & sodid they all before the H new land of mountains

sun was quite set. though it were but a cloud no bigger than a man's hand Babennight fell they struck not sail, but went forth toward the land fair and softly: forit was early summer. so that the nights were neither long nor dark. BAT when it was broad daylight. they opened a land, a long shore of rocks & mountains, & nought else that they could see at first. Nevertheless as day wore & they drewnigher. first they saw how the mountains fell away from the sea, and were behind a long wall of sheer cliff: and coming nigher yet, they beheld a green plain going up after a little in green bents & slopes to the feet of the said cliff, wall. No city nor haven did they see there, not even when they were far nigher to the land: nevertheless whereas they hankered for the peace of the green earth after all the tossing and unrest of thesea. & whereas also they doubted not to find at the least good and fresh water, and belike other bait in the plain under the mountains, they still sailed on not unmerrily: so that by nightfall 26

they cast anchor in five/fathom water H river & hard by the shore.

SEXT morning they found that stead A they were lying a little way off thereby the mouth of a river not right great: so they put out their boats and towed the ship up into the said river, and when they had gone up it for a mile or thereabouts they found the seawater failed. for little was the ebb & flow of the tide on that coast. Then was the river deep and clear, running between smooth grassy land like to meadows. Also on their left board they saw presently three head of neat cattle going. as if in a meadow of a homestead in their own land, and a few sheep: and thereafter, about a bow/draught from the river, they saw a little house of wood & straw/thatch under a wooded mound. & with orchard trees about it. They wondered little thereat, for they knew no cause why that land should not be builded, though it were in the far outlands. however. they drew their ship up to the bank, thinking that they would at least abide awhile & ask tid-

H new comer

ings and have some refreshing of the green plain, which was so lovely and pleasant.

WAT while they were busied herein they saw a man come out of the house, and down to the river to meet them : and they soon saw that he was tall & old, long/hoary of hair and beard. & clad mostly in the skins of beasts. B he drew nigh without any fear or mistrust, and coming close to them gave them the sele of the day in a kindly and pleasant voice. The shipmaster greeted him in his turn. and said withal: Old man, art thou the king of this country? IF The elder laughed: It hath had none other along while, said he; and at least there is no other son of Hdam here to gainsay. B Thou art alone here then? said the master D Yea, said the old man, save for the beasts of the field & the wood, and the creeping things, and fowl. Therefore it is sweet to me to hear vour voices. BSaid the master: There be the other houses of the town? The old man laughed. Said he: Mhen 28

I said that I was alone. I meant that Of the I was alone in the land and not only Bears alone in this stead. There is no house save this betwirt the sea & the dwelllings of the Bears. over the cliff / wall vonder, vea and a long way over it B Yea, quoth the shipmaster grinning, and be the bears of thy country so manlike, that they dwell in builded houses? J The old man shook his head. Sir. said he. as to their bodily fashion, it is altogether manlike, save that they be one and all higher and bigger than most. for they be bears only in name: they be a nation of half wild men: for I have been told by them that there be many more than that tribe whose folk I have seen, and that they spread wide about behind these mountains from east to west. Nowsir, as to their souls and understandings I warrant them not: for miscreants they be, trowing neither in God nor his ballows. Said the master: Trow they in Mahound then? B Nay, said the elder. I wot not for sure that they have so much as a false God: though

fresh victual for the mariners

I have it from them that they worship a certain woman with mickle worship E Then spake Malter: Yea, good sir. & how knowest thou that? dost thou deal with them at all? @ Said the old man: Whiles some of that folk come hither & have of me what I can spare: a calf or two. or a half/dozen of lambs or hoggets: or a skin of wine or cvderof mineown making: and they give me in return such things as I can use. as skins of hart and bear & other peltries: for now I am old, I can but little of the hunting hereabout. Mhiles. also, they bring little lumps of pure copper. and would give me gold also. but it is of little use in this lonely land. Sooth to say, to me they are not masterful or rough , handed ; but glad am I that they have been here but of late, and are not like to come again this while: for terrible they are of aspect. and whereas ve be aliens, belike they would not hold their hands from off vou: & moreover ve have weapons and other matters which they would covet sorely @Quoth the master: Since thou 30

dealest with these wild men, will yenot H boundeal with us in chaffer? for whereas we teous are come from long travel, we hanker Carl after fresh victual, and here aboard are many things which were for thine avail Baid the old man: Hll that I have is yours, so that ye do but leave me enough till my next ingathering: of wine and cyder, such as it is. I have plenty for your service; ye may drink it till it is all gone, if ye will: a little corn & meal I have, but not much: vet are vewelcome thereto, since the stand, ing corn in my garth is done blossom, ing, and I have other meat. Cheeses have I and dried fish: take what ve will thereof. But as to my neat and sheep, if ye have sore need of any, and will have them. I may not say you nay: but I pray you if ye may do without them. not to take my milch beasts or their engenderers; for, as ye have heard me say, the Bearsfolk have been here but of late, and they have had of me all I mightspare: but now let me tell vou. if ye long after flesh/meat, that there is venison of hart and hind, yea, and of

Of the wilddeer

buck and doe, to be had on this plain. and about the little woods at the feet of the rock/wall vonder: neither are they exceeding wild; for since I may not take them. I scare them not, & no other man do they see to hurt them: for the Bear/folk come straight to my house, and fare straight home thence. But I will lead you the nighest way to where the venison is easiest to be got, ten. As to the wares in your ship. if ve will give me aught I will take it with a good will; and chiefly if ye have a fair knife or two and a roll of linen cloth. that were a good refreshment to me. But in any case what I have to give is free to you and welcome.

DE shipmaster laughed: friend, said he, we can thee mickle thanks for all that thou biddest us. And wot well that we be no lifters or seathieves to take thy livelihood from thee. So to/morrow, if thou wilt, we will go with thee and upraise the hunt, & mean/ while we will come aland, & walk on the green grass, and water our ship with thy good fresh water.

So the old carle went back to his house They tomake them ready what cheer he might. feast and the shipmen, who were twenty and on the one, all told, what with the mariners & meadow Hrnold and Malter's servants.went ashore,all but two who watched the ship & abode their turn. They went well weaponed. for both the master and Walter deemed wariness wisdom, lest all might not be so good as it seemed. They took of their sail cloths ashore. & tilted them in on the meadow betwixt the house & the ship, and the carle brought them what he had for their avail, of fresh fruits.andcheeses.andmilk.andwine, and cyder, and honey, and there they feasted nowise ill, and were right fain.

Chapter VI. The old man tells Malter of himself. Malter sees a shard in the cliff/wall & &

Their meat and drink the master and the shipmen went about the watering of the ship, and the others strayed off along the Malter talks alone with the carle meadow, so that presently Malter was leftalone with the carle, & fell to speech with him and said: father, meseem eth thou shouldest have some strange tale to tell, & as yet we have asked thee of nought save meat for our bellies: now if I ask thee concerning thy life, and how thou camest hither, & abided here, wilt thou tell me aught?

be old man smiled on him and said: Son, my tale were long to tell; and maybappen concerning much thereof my memory should fail me; and withal there is grief therein, which I were loth to awaken: nevertheless if thou ask, I will answer as I may, & in any case will tell thee nought save the truth.

HID Malter: Mell then, hast thou been long here? I Yea, said the carle, since I was a young man, and a stalwarth knight. Said Malter: This house, didst thou build it, and raise these garths, and plant orchard and vineyard, and gather together the neat & the sheep, or did some other do all this for thee?

Baid the carle: I did none of all this: there was one here before me. and Ientered into his inheritance, as though this were a lordly manor. with a fair castlethereon. and all well stocked and plenished @ Said Malter: Didst thou find thy foregoer alive here? B Yea, said the elder, vet he lived but for a little while after I came to him.

E was silent a while, and then he E was silent a while, and the so would said: I slew him: even so would be have it, though I bade him a

better lot, # Said Malter: Didst thou come hither of thine own will? @ Mav, happen, said the carle: who knoweth? Now have I no will to do either this or that. It is wont that maketh me do. or refrain J Said Malter: Tell me this: why didst thou slay the man? did he any scathe to thee? B Said the elder: When I slew him. I deemed that he was doing me all scathe: but now I know that it was not so. Thus it was: I would needs go where he had been ber fore, and he stood in the path against me; and I overthrew him, and went on the way I would @ That came thereof? d 2 35

Of him who was beforethe carle

H downríght nay, say

said Malter & Evil came of it, said the carle.

DEN was Walter silent a while, and the old man spake nothing; but there came a smile in his face that was both sly and somewhat sad. Walter looked on him and said: Was it from bence that thou wouldst go that road? Yea, said the carle Said Wal ter: And now wilt thou tell me what that road was; whither it went and whereto it led, that thou must needs wend it, though thy first stride were over a dead man? I will not tell thee, said the carle For the hey held their peace, both of them, and thereafter got on to other talk of no import.

O wore the day till night came; and they slept safely, and on the morrow after they had broken their fast, the more part of them set off with the carle to the hunting, and they went, all of them, a three hours' faring towards the foot of the cliffs, which was all grown over with coppice, hazel & thorn, with here & there a big oak or ash/tree; there it was, said the old man,

where the venison was most and best.

Sf their hunting need nought be said, saving that when the carle A had put them on the track of the deer & shown them what to do. he came back again with Malter, who had no great lust for the hunting. & sorely longed to have some more talk with the said carle. He for his part seemed nought loth thereto, and so led Walter to a mound or hillock amidst the clear of the plain, whence all was to be seen save where the wood covered it: but just before where they now lay down there was no wood, save low bushes, ber twirt them & the rock/wall: & Malter noted that whereas otherwhere. save in one place whereto their eves were turn, ed, the cliffs seemed well nigh or quite sheer, or indeed in some places beetling over, in that said place they fell away from each other on either side: and before this sinking was a slope or scree, that went gently up toward the sinking of the wall. Malter looked long and earnestly at this place, and spake nought, till the carle said : Mhat 1 thou 37

Of the bunting. and how Malter abode behind with the carle

Of the shard in the cliff, wall

hast found something before thee to look on. Mhatis it then? @Quoth Mal ter: Some would say that where vonder slopes run together up towards that sinking in the cliff, wall there will be a pass into the country beyond The carle smiled & said : Vea. son : nor. so saying, would they err: for that is the pass into the Bear/country.whereby those huge men come down to chaft fer with me J Yea, said Malter; and therewith he turned him a little, and scanned the rock/wall. & saw how a few miles from that pass it turned somewhat sharply toward the sea, narrowing the plain much there, till it made a bight, the face whereof looked wellnigh north, instead of west, as did the more part of the wall. And in the midst of that northern, looking bight was a dark place which seemed to Walter like a downright shard in the cliff. for the face of the wall was of a bleak grev. and it was but little furrowed @ So then Malter spake: Lo. old friend. there yonder is again a place that meseemethis a pass; whereunto doth that one 38

lead? And he pointed to it: but the old man did not follow the pointing of his finger.but. looking down on the ground, answered confusedly. & said: Maybe: I wot not. I deem that it also leadeth into the Bear/country by a round/about road. It leadeth into the far land.

Malter has a deeming concerning that shard

MALTER answered nought: for a strange thought had

come uppermost in his mind. that the carle knew far more than he would say of that pass. & that he him, self might be led thereby to find the wondrous three. He caught his breath hardly, and his heart knocked against his ribs: but he refrained from speakingforalong while: but at last he spake in a sharp hard voice, which he scarce knew for his own: father. tell me. I ad, iure thee by God and All hallows, was it through vonder shard that the road lay, when thou must needs make thy first stride over a dead man?

BE old man spake not a while. then he raised his head, & looked Malter full in the eyes, and said

A lie downright in a steady voice: NO, IT MHS NOT. Thereafter they sat looking at each other a while: but at last Malter turned his eves away, but knew not what they beheld nor where he was, but he was as one in a swoon. For beknew full well that the carle had lied to him. and that he might as well have said ave as no. and told him. that it verily was by that same shard that he had stridden over a dead man. Nevertheless he made as little semblance thereof as he might, and presently came to bimself, and fell to talking of other matters, that had nought to do with the adventures of the land. But after a while he spake suddenly, and said: My master, I was thinking of a thing J Yea, of what? said the carle @ Of this. said Malter: that here in this land be strange adventures toward, and that if we, and I in especial, were to turn our backs on them, and go home with nothing done. it were pity of our lives: for all will be dull and deedless there. I was deeming it were good if we tried the adventure Baid the old man,

rising upon his elbow & staring stern, The carle ly on him. Said Malter: The wending tells of yonder pass to the eastward, whereby the Bearthe huge men come to thee from out folk and of the Bear/country: that we might see what should come thereof B The carle leaned back again, and smiled & shook his head, & spake: That adventure were speedily proven: death would come of it, my son B Yea, & how? said Malter E The carle said: The big men would take thee, and offer thee up as a blood, offering to that woman, who is their Mawmet. Hnd if ye go all, then shall they do the like with all of you, @Said Malter: Is that sure? I Dead sure. said the carle B how knowest thou this? said Malter J l have been there mvself, said the carle @ Yea, said Wal ter, but thou camest away whole, BHrt thou sure thereof? said the carle. Thou art alive yet, old man, said Malter, for I have seen thee eat thy meat. which abosts use not to do. And he laughed But the old man answered soberly: If I escaped, it was by this. that another woman saved me, & not 41

theirways

The carle warneth Walter against the adventure often shall that befall. Nor wholly was I saved; my body escaped forsooth. But where is my soul? There is my heart, and my life? Young man, I rede thee, try no such adventure; but go home to thy kindred if thou canst, Moreover, wouldst thou fare alone? The others shall hinder thee Said The others shall hinder thee Said The others shall hinder thee Said Malter, I am the master; they shall do as I bid them: besides, they will be well pleased to share my goods amongst them if I give them a writing to clear them of all charges which might be brought against them.

Y son1 my son1 said the carle, I pray the ego not to thy death Malter beard him silently, but as if he were persuaded to refrain; and then the old man fell to, and told him much concerning this Bear/folk & their customs, speaking very freely of them; but Malter's ears were scarce open to this talk: whereas he deemed that he should have nought to do with those wild men; and he durst not ask again concerning the country whereto led the pass on the northward.

Chapter VII. Malter comes to the shard in the rock/wall 森菜菜

> S they were in converse thus, they heard the hun, ters blowing on their horns all together; where, on the old man arose, & said: I deem by the blow,

ing that the hunt will be over and done. and that they be blowing on their fellows who have gone scatter/mealabout the wood. It is now some five hours af, ter noon, and thy men will be getting back with their venison. & will be fain, est of the victuals they have caught; therefore will I hasten on before, and get ready fire and water and other mat, ters for the cooking. Milt thou come with me, young master. or abide thy men here? @ Malter said lightly: I will rest and abide them here: since I cannot fail to see them hence as they go on their ways to thine house. And it may be well that I be at hand to command them and forbid, and put some order amongst them, for rough play, mates they be, some of them, and now

Malter's folk are coming backfrom the hunting

Malter maketh hím ready

all beated with the hunting and the joy of the green earth. Thus he spoke, as if nought were toward save supper and bed; but inwardly hope and fear were contending in him, and again his heart beat so hard, that he deemed that the carle must surely hear it. But the old man took him but according to his out/ ward seeming, and nodded his head, & went away quietly toward his house.

DEN he had been gone a little, Calter rose up heedfully; he had with him a scrip where, in was some cheese and hard, fish, & a littleflasket of wine; a short bow he had with him, and a quiver of arrows; & he was girt with a strong & good sword, and a wood, knife withal. De looked to all this gear that it was nought amiss, and then speedily went down off the mound, and when he was come down, he found that it covered him from men coming out of the wood, if he went straight thence to that shard of the rock, wall where was the pass that led southward.

SOM it is no nay that thither. Besuna ward be turned, and went wise, dereth ly, lest the carle should make a bim from backward cast, and see him, or lest any his folk straggler of his own folk might happen upon him B for to say sooth. he deemed that did they wind him, they would be like to let him of his journey. he had noted the bearings of the cliffs nigh the shard, and whereas he could see their heads everywhere except from the depths of the thicket, he was not like to go astray.

C had made no great way ere be heard the horns blowing all to-gether again in one place, and looking thitherward through the leafy boughs (for he was now amidst of a thicket) he saw his men thronging the mound. & had no doubt therefore that they were blowing on him; but being well under cover he heeded it nought. & lving still a little, saw them go down off the mound and go all of them toward the carle's house. still blowing as they went, but not faring scatter/meal. Therefore it was clear that they were

De entereth the Dass

nought troubled about him.

Ohewent on his way to the shard: and there is nothing to say of his journey till he got before it with the last of the clear day, and entered it straightway. It was in sooth a downright breach or cleft in the rockwall, and there was no hill or bent leading up to it, nothing but a tumble of stones before it, which was somewhat uneasy going, yet needed nought but labour to overcome it, and when he had got over this, and was in the very pass itself, he found it no ill going: forsooth at first it was little worse than a rough road betwixt two great stony slopes, though a little trickle of water randown amidst of it. So, though it was so nigh nightfall, yet Malter pressed on, yea, and long after the very night was come. for the moon rose wide and bright a little after nightfall. But at last he had gone so long, and was so wearied, that he deemed it nought but wisdom to rest him, and so lay down on a piece of green/sward betwixt the stones.when he had eaten amorsel out

of his satchel, and drunk of the water The first of the stream. There as he lay, if he morning had any doubt of peril, his weariness in the soon made it all one to him, for presently he was sleeping as soundly as any man in Langton on Bolm.

Chapter VIII. Malter wends the Maste

0

Hy was yet young when he awoke : he leapt to his feet, & went down to the stream and drank of its waters, and washed the night off him in a pool

thereof, and then set forth on his way again. Alben he had gone some three hours, the road, which had been going up all the way, but somewhat gently, grew steeper, & the bent on either side lowered, & lowered, till it sank at last altogether, and then was he on a rough mountain/neck with little grass, & no water; save that now & again was a soft place with a flow amidst of it, and such places he must needs fetch a compass about, lest he be mired. The gave himself but littlerest, eating what henceds The wending of the Maste

must as he went. The day was bright & calm, so that the sun was never hidden, and he steered by it due south. All that day he went, and found no more change in that huge neck, save that whiles it was more & whiles less steep. H little before nightfall he happened on a shallow pool some twenty vards over: and he deemed it good to rest there.since there was water for his avail. though hemight have made somewhat more out of the tail end of the day.

BEN dawn came again he awoke&arose,norspentmuch time over his breakfast; but pressed on all he might; and now he said to himself, that whatsoever other períl were athwart his way. he was out of the danger of the chase of his own folk.

LL this while he had seen no four, footed beast, save now & again a hill fox, and once some outlandish kind of hare: and of fowl but very few: a crow or two, a long/winged hawk, and twice an eagle high up aloft.

OGAIN, the third night, he slept The fint the stony wilderness, which weng still led him up and up. Only of the toward the end of the day, himseemed that it had been less steep for a long while: otherwise nought was changed. on all sides it was nought but the endless neck, wherefrom nought could be seen, but some other part of itself. This fourth night withal he found no water whereby he might rest, so that beawokeparched, and longing to drink just when the dawn was at its coldest.

NAT on the fifth morrow the groundrose but little, & at last, when he had been going wearily

a long while, & now, hard on noon/tide. his thirst grieved him sorely, he came on a spring welling out from under a highrock, the water where from trickled feebly away. So eager was he to drink, that at first he heeded nought else: but when his thirst was fully quenched his eves caught sight of the stream which flowed from the well, & hegaveashout, for lo1 it was running south. Mherefore it was with a merry heart that he 49

e

wending Maste

The wending of the Maste went on, and as he went, came on more streams, all running south or thereabouts. Debastened on all he might, but in despite of all the speed hemade, and that he felt the land now going down southward, night overtook him in that same wilderness. Yet when he stayed at last for sheer weariness, he lay down in what he deemed by the moonlight to be a shallow valley, with a ridge at the southern end thereof.

Esleptlong, and when heawoke thesun was high in the heavens. and never was brighter or clearer morning on the earth than was that. Be arose and ate of what little was yet left him. and drank of the water of a stream which he had followed the evening before, and beside which he had laid him down: and then set forth again with no great hope to come on new tidings that day. But yet when he was fairly afoot, himseemed that there was something new in the air which he breathed, that was soft and bore sweet scents home to him: whereas heretofore. & that especially for the last three or four days.

it had been harsh and void, like the face H fair of the desert itself. land in the

Oon bewent, and presently was offing mounting the ridge aforesaid. and, as oft happens when one climbs a steep place, he kept his eyes on the ground, till he felt he was on the top of the ridge. Then he stopped to takebreath. & raised his head & looked. and loi be was verily on the brow of the great mountain/neck. and down below him was the hanging of the great hill slopes, which fell down, not slowly. as those he had been those days a mounting, but speedily enough, though with little of broken places or sheer cliffs. But beyond this last of the desert there was before him a lovely land of wooded hills, green plains, and little valleys. stretching out far & wide. till it ended at last in great blue mountains & white snowy peaks beyond them.

hen for very surprise of joy his spirit wavered, & he felt faint and dizzy, so that he was fain to sit down a while and cover his face with his hands. Dresently he came to his sober

e2

mind again, and stood up and looked forth keenly, and saw no sign of any dwelling of man. But he said to himself that that might well be because the good & well grassed land was still so faroff, & that he might yet look to find men and their dwellings when he had left the mountain wilderness quite ber hind him. So therewith he fell to going his ways down the mountain, and lost little time therein, whereas he now had his livelihood to look to.

Chapter IX. Malter happeneth on the first of those three creatures

BAC with one thing, what with another, as his having to turn out of his way for sheer rocks, or for slopes so steep that hemight not

try the peril of them, & again for bogs impassable, he was fully three days more before he had quite come out of the stony waste, and by that time, though he had never lacked water, his scanty victual was quite done, for all his careful husbandry thereof. But

this troubled him little, whereas he A sweet looked to find wild fruits here & there, sleep and to shoot some small deer, as hare or conev. and make a shift to cook the same, since he had with him flint and fire/steel.Moreoverthefurtherhewent. the surer he was that he should soon come across a dwelling, so smooth & fair as everything looked before him. And he had scant fear, save that he might happen on men who should enthrall him.

maat when he was come down s past the first green slopes, he was so worn, that he said to

himself that rest was better than meat. so little as he had slept for the last three days: so he laid him down under an ash/tree by a stream/side, nor asked what was orclock, but had his fill of sleep, and even when he awoke in the fresh morning was little fain of rising. but lay betwixt sleeping and waking for some three hours more: then he arose, and went further down the next green bent, yet somewhat slowly because of his hunger weakness. And the

noíse

H strange scent of that fair land came up to him & terrible like the odour of one great nosegay.

O he came to where the land was level, and there were many trees, as oakandash, and sweet/chest/ nut and wych/elm, and hornbeam and quickenstree, not growing in a close wood or tangled thicket, but set as though in order on the flowery green, sward, even as it might be in a great king's park @Socame he to a big bird, cherry, whereof many boughs hung low down laden with fruit: his belly rejoiced at the sight, and he caught hold of a bough, and fell to plucking and eating. But whiles he was amidst of this, he heard suddenly, close anigh him, a strange noise of roaring and braving, not very great, but exceeding fierce and terrible, and not like to the voice of any beast that he knew. As has been aforesaid. Malter was no faintheart; but what with the weakness of his travail and hunger, what with the strangeness of his adventure and his loneliness, his spirit failed him; he turned round towards the noise. his

knees shook & he trembled: this way An evil and that he looked, and then gave a creature great cry & tumbled down in a swoon; for close before him, at his very feet, was the dwarf whose image he had seen before, clad in his yellow coat, & grinning up at him from his hideous hairy countenance.

Oa long he lay there as one K dead, he knew not, but when dead, he knew not, but when he woke again there was the dwarf sitting on his hams close by him. And when he lifted up his head. the dwarf sent out that fearful barsh voiceagain: but this time Maltercould make out words therein. & knew that the creature spoke and said: B how now 1 and art thou? Thence comest? That wantest? B Malter sat up and said: Iam a man: I hight Golden Wal ter: I come from Langton: I want victual B Said the dwarf, writhing his face grievously, & laughing forsooth: I know it all: I asked thee to see what wise thou would st lie. I was sent forth to look for thee: and I have brought thee loathsome bread with me. such as

The passion of the Evil Thing

ve aliens must needs eat: take it 1.0 Therewith he drew a loaf from a satch el which he bore, and thrust it towards Malter. who took it somewhat doubt, fully for all his hunger, B The dwarf velled at him: Hrt thou dainty, alien? Mouldst thou have flesh? Mell, give me thy bow & an arrow or two. since thou artlazy/sick,&I will get thee a conevor a hare. or a quail maybe. Hh. I forgot : thou art dainty, and wilt not eat flesh as I do. blood & all together, but must needs half burn it in the fire, or mar it with hot water: as they say my Lady does: oras the Wretch. the Thing does: I know that, for I have seen It eating B Nay, said Walter, this sufficeth: & he fell to eating the bread, which was sweet between his teeth. Then when be had eaten a while. for hunger compelled him, he said to the dwarf: But what meanest thou by the Aretch and the Thing? Hnd what Lady is thy Lady? E The creature let out another wordless roar as of furious anger: & then the words came: It hath a face white and red, like to thine; and hands 56

white as thine. vea, but whiter; & the The paslike it is underneath its raiment, only sion of whiter still: for I have seen It ... yes. I the Evil have seen It; ah yes and yes and ves B And therewith his words ran into gibber and velling, and herolled about and smote at the grass: but in a while be grew quiet again and sat still, and then fell to laughing horribly again. & then said: But thou, fool, wilt think It fair if thou fallest into It's hands. and wilt repent it thereafter. as I did. Oh. the mocking and gibes of It. and the tears and shricks of It; and the knife Mhat savest thou of my Lady? ... That Lady? O alien, what other Lar dvisthere? And what shall I tell thee of her? it is like that she made me. as she made the Bear men. But she made not the Mretch. the Thing: & she hateth It sorely. as I do. And some day to come E Thereat he brake off and fell to wordless vellingalong while, & thereafter spake all panting: Now I have told thee overmuch, and O if my Lady come to hear thereof. Now I will go @ And therewith he took out two more

Thing

Bread to eat & fear to brood over loaves from his wallet. & tossed them to Walter, and so turned and went his ways: whiles walking upright. as Malter had seen his image on the quay of Langton: whiles bounding and rolling like a ball thrown by a lad; whiles scuttling along on all fours like an evil beast, and ever and anon giving forth that harsh and evil cry . # Malter sat a while after he was out of sight. so stricken with borror and loathing and a fear of he knew not what, that he might not move. Then he plucked up a heart, and looked to his weapons and put the other loaves into his scrip B Then he arose and went his ways won, dering, yea and dreading, what kind of creature he should next fall in with. for soothly it seemed to him that it would be worse than death if they were all such as this one: and that if it were so, he must needs slav and be slain.

Chapter X. Malter happeneth on another creature in the strange Land A

UCas be went on through forward the fair and sweet land so bright and sunlitten, and be now rested & fed, the borror&fear ran off from him, and be wandered on

merrily, neither did aught befall him save the coming of night, when he laid him down under a great spreading oak with his drawn sword ready to hand, & fellasleep at once, and woke not till the sun was high.

DEN be arose and went on his way again; and the land was no worser than yesterday; but even better, it might be; the greensward more flowery, the oaks & chestnuts greater. Deer of diverse kinds be saw, & might easily have got his meat thereof; but be meddled not with them since behad his bread, & was timorous of lighting a fire. Mithal be doubted little of having some entertainment; & that, might be, nought evil; since even that fearful dwarf had been courteous to him after

Malter goeth forward his kind, and had done him good and znotharm. But of the happening on the Aretch&the Thing, where of the dwarf by spake, he was yet somewhat a feard.

> fTERhehadgoneawhile and whenas the summer morn was at its brightest, he sawalittle way a head a grey rock rising up from amidst of a ring of oak-

trees: so he turned thither straightway: for in this plain land he had seen no rocks heretofore: and as hewent he saw that there was a fountain gushingout from under the rock, which ran thence in a fair little stream. And when he had the rock and the fountain and the stream clear before him. lol a child of Adam sitting beside the fountain under the shadow of the rock. Bedrew a little nigher. Ethen he saw that it was a woman, clad in green like the sward whereon she lay. She was playing with the welling out of the water. & she had trussed up her sleeves to the shoulder that she might thrust her bare arms therein. Her shoes of black leather lay 60

on the grass beside her. Therefeet and H shameleas vet shone with the brook. fast

ELIKE amidst the splashing & maiden clatter of the water she did not hear him drawing nigh. so that he was close to her before she lifted up her face & saw him, and he beheld her. that it was the maiden of the thriceseen pageant. She reddened when she saw him. & hastily covered up her leas with her gown/skirt, & drew down the sleeves over her arms, but otherwise stirred not. As for him. he stood still. striving to speak to her: but no word might he bring out, and his heart beat sorely.

AT the maiden spake to him in a clear sweet voice, wherein was now no trouble: Thou art an alien, art thou not? for I have not seen thee before Fyea, he said, I am an alien; wilt thou be good to me? B She said: And why not? I was a fraid at first, for I thought it had been the King's Son. I looked to see none other: for of goodly men he has been the only one here in the land this long while, till thy 61

together

They talk coming, Besaid: Didstthoulook for my coming at about this time? BO nav. she said: how might 1? # Said Walter: I wot not: but the other man seemed to be looking for me, and knew of me, and he brought me bread to eat Bhe looked on him anxiously, and grew somewhat pale. as she said: What otherone? @Now Malterdidnotknow what the dwarf might be to her. fellow, servant or what not, so he would not showhis loathing of him: but answer/ ed wisely: The little man in the vellow raiment.

Wat when she heard that word. she went suddenly very pale, & leaned her head aback, and beat the air with her hands: but said presently in a faint voice: I pray thee talk not of that one while I am by, nor even think of him. if thou mayest forbear. E spake not, and she was a little while before she came to herself again; then she opened hereyes, & looked upon Malter & smiled kindly on him, as though to ask his pardon for having scared him. Then she rose 62

up in her place, and stood before him; The Maid and they were nigh together, for the must have stream betwixt them was little, But time for he still looked anxiously upon her and pondersaid: have I burt thee? I pray thy pardon @She looked on him more sweetly still, and said: O nay; thou wouldst not hurt me, thou ! E Chen she blushed very red, & he in like wise; but afterwards she turned pale. Elaida hand on her breast, & Malter cried out hastily: Omel I have hurt thee again. Aberein have I done amiss? @ In nought, in nought, she said; but I am troubled, I wotnotwherefore; somethoughthath taken hold of me, and I know it not. MayhappeninalittlewhileIshallknow what troubles me. Now I bid thee depart from me a little, and I will abide here: & when thou comest back, it will eitherbethat I have found it out or not: and in either case I will tell thee.

DE spoke earnestly to him; but he said: how long shall I abide away? her face was troubled as she answered him: for no long while.

ing

Malter comes back e smiled on herand turned away, and went a space to the other side of the oak/trees, whence she was still within evershot. There he abode until the time seemed long to him: but he schooled himself and forbore: for he said : Lest she send me away again. Sobe abided until again the time seem, ed long to him. & she called not to him: but once again he forbore to go; then at last he arose, and his heart beat and he trembled, and he walked back again speedily, and came to the maiden, who was still standing by the rock of the spring, her arms hanging down, her eves downcast. She looked up at him as he drew nigh. & her face changed with eagerness as she said: I am glad thou art come back, though it be no long while since thy departure (sooth to say it was scarce half an hour in all). Nevertheless I have been thinking many things, and thereof will I now tell thee Be said: Maiden, there is a river ber twixt us, though it be no bigone. Shall Inot stride over. and come to thee, that we may sit down together side by side

on the green grass? WNay, she said, The Maid not yet; tarry a while till I have told tellethher thee of matters. I must now tell thee finding of my thoughts in order. For colour went and came now, and she plaited the folds of her gown with restless fingers. Ht last she said: Now the first thing is this: that though thou hast seen me first only within this hour. thou hast set thine heart upon me to have me for thy speech friend and thy darling. And if this be not so, then is all my speech, yea & all my hope, come to an end at once B O yeal said Malter. even so it is : but how thou hast found this out I wot not; since now for the first time I say it, that thou art indeed my love, and my dear and my darling JF Bush, she said, hush! lest the wood have ears. & thy speech is loud: abide, & I shall tell thee how I know it. Mhether this thy love shall outlast the first time that thou holdest my body in thine arms, I wot not, nor dost thou. But sore is my hope that it may be so: for I also, though it be but scarce an hour since I set eyes on thee, have cast

f

not be touched

She will mine eves on thee to have thee for my love and my darling, and my speechfriend. And this is how I wot that thou lovest me, my friend. Now is all this dear & joyful, and overflows my heart with sweetness. But now must I tell thee of the fear and the evil which lieth behind it.

BEN Malter stretched out his hands to her, & cried out: Yea, yea | But whatever evil entangle us, now we both know these two things, to wit, that thou lovest me, & I thee, wilt thou not come hither, that I may cast mine arms about thee, & kiss thee.if not thy kind lips or thy friendly face at all, yet at least thy dear hand: yea.that I may touch thy body in some wise? @She looked on him steadily. & said softly: Nay, this above all things must not be; and that it may not be is a part of the evil which entangles us. But hearken, friend, once again I tell thee that thy voice is over loud in this wilderness fruitful of evil. Now I have told thee, indeed, of two things where, of we both wot; but next I must needs 66

tell thee of things whereof I wot, and They dethou wottest not. Vet this were better. part from that thou pledge thy word not to touch so much as one of my hands, and that we go together a little way hence away from these tumbled stones. & sit down upon the open greensward; whereas here is cover if there be spying abroad BAgain.as she spoke.she turned very pale: but Malter said: Since it must be so. I pledge thee my word to thee as I love thee. # And therewith she knelt down. & did on her foot gear, and then sprang lightly over the rivulet; & then the twain of them went side by side some half a furlong thence, and sat down, shadowed by the boughs of a slim quicken/tree growing up out of the greensward, whereon for a good space around was neither bush nor brake.

DERE began the maiden to talk soberly, and said: This is what I must needs say to thee

now, that thou art come into a land per rilous for any one that loveth aught of good: from which, forsooth, I were fain that thou wert gotten away safely, 67

f2

the fountain that they may talk safelv

The Maid telleth of the Mistress even though I should die of longing for thee. As for myself. my peril is, in a measure, less than thine: I mean the peril of death. But lo. thou. this iron on my foot is token that I am a thrall. and thou knowest in what wise thralls must pav for transgressions. Furthermore. of what I am, and how I came hither. time would fail me to tell: but somewhile, maybe, I shall tell thee. I serve an evil mistress, of whom I may say that scarce I wot if she be a woman or not: but by some creatures is she accounted for a god, & as a god is heried; and surely never god was crueller nor colder than she. Me she hateth sorely: vet if she hated me little or nought. small were the gain to me if it were her pleasure to deal hardly by me. But as thingsnoware, & are like to be, it would not be for her pleasure, but for her pain and loss, to make an end of me, therefore. as I said e'en now. mv mere life is not in peril with her: unless, perchance. some sudden passion get the better of her, and she slay me, and repent of it thereafter. for so it is. that if it be the 68

least evil of her conditions that she is And of wanton, at least wanton she is to the theKing's letter. Many a time bath she cast the Son net for the catching of some goodly voungman: & her latest prev (save it be thou) is the young man whom I named. when first I saw thee, by the name of the King's Son. he is with us vet, and I fear him: for of late hath he wearied of her. though it is but plain truth to say of her, that she is the wonder of all Beauties of the Morld. he hath wearing ed of her. I say, and hath cast his eyes uponme. & if I were heedless, he would betray me to the uttermost of the wrath of my mistress. for needs must I say of him, though be be a goodly man, and now fallen into thralldom. that he hath no bowels of compassion: but is a das, tard, who for an hour's pleasure would undo me. and thereafter stand by smile ing and taking my mistress's pardon with good cheer, while for me would be no pardon. Seest thou, therefore, how it is with me between these two cruel fools? And moreover there are others of whom I will not even speak to thee 60

The grief of the Maid

Barauddenly the Maidleft weep, ing, and said in a changed voice: friend, whereas thou speakest of deliveringme. it is more like that I shall deliver thee. And now I pray thy pardon for thus grieving thee with my grief, and that more especially because thou mayst not solace thy grief with kisses and caresses; but soit was, that for once I was smitten by the thought of the anguish of this land. & the joy of all the world besides B Therewith she caught her breath in a half/sob.but refrained her & went on : Now dear friend and darling, take good heed to all that I shall say to thee, whereas thou must

doafter the teaching of my words. And Walter first.I deem by the monster having met tells of thee at the gates of the land, & refresh, his vision ed thee. that the Mistress hath looked for thy coming; nay, by thy coming bither at all. that she bath cast her net & caught thee. Bast thou noted aught that might seem to make this morelike? @Said Malter: Three times in fullday, light have I seen go past me the images of the monster and thee and a glorious lady, even as if ve were alive, B And therewith he told her in few words how it had gone with him since that day on the quay at Langton.

The said: Then it is no longer perhaps, but certain, that thou art her latest catch; and even so Ideemed from the first: &. dear friend. this is why I have not suffered thee to kiss or caress me. so sore as I longed for thee. for the Mistress will have thee for heronly, and hath lured thee hither

for nought else : and she is wise in wizardry (even as some deal am I), & wert thou to touch me with hand or mouth on my naked flesh, vea. or were it even

pondereth

The Maid my raiment, then would she scent the savour of thy love upon me, and then, though it may be she would spare thee, she would not spare me.

DEN was she silent a little. and seemed very downcast. & Mal terheld his peace from grief &

confusion & helplessness: for of wizardry be knew nought.

Clast the Maid spake again, and said:Nevertheless we will not die redeless. Now thou must look to this, that from henceforward it is thee. & not the King's Son, whom she desir, eth. & that so much the more that she hath not set eves on thee. Remember this. whatsoever her seeming may be to thee. Now. therefore. shall the King's Son be free, though he know it not, to cast his love on whomso he will: and. in away, Lalsoshall be free to yeasay him. Though, forsooth, so fulfilled is she with malice and spite, that even then shemay turn round on me to punishme for doing that which she would have me do. Now let me think of it.

DEN was she silent a good while, and spoke at last: Yea, all things

are perilous, and a perilous rede I have thought of, whereof I will not tell thee as vet: so waste not the short while by asking me. At least the worst will be no worse than what shall come if we strive not against it. And now, my friend, amongst perils it is growing more and more perilous that we twain should be longer together. But I would say one thing yet; and maybe another thereafter. Thou hast cast thy love upon one who will be true to thee. whatsoever may befall; yet is she a guileful creature, and might not help it her life long, and now for thy very sake must needs be more quileful now than ever before. And as for me, the quileful, my love have I cast upon a lovely man, and one true and simple. and a stout/heart; but at such a pinch is he, that if he withstand all temptation, his withstanding may belike undo both him and me. Therefore swear we both of us. that by both of us shall all quile & all falling away be forgiven 73

She hath a hidden rede

They swear leal love together

on the day when we shall be free to love each the other as our hearts will.

HLTER cried out: O love, I swear it indeed! thou art my hallow, and I will swear it as on the relics of a hallow; on thy hands and thy feet I swear it F The words seemed to her a dear caress; and she laughed, and blushed, and looked full kindly on him; and then her face grew solemn, and she said: On thy life I swear it!

DEN she said: Now is there nought for thee to do but to go hence straight to the Golden

Bouse, which is my Mistress's bouse, and the only house in this land (save one which I may not see), and lieth southward no long way. Bow she will deal with thee, I wot not; but all I have said of her and thee and the King's Son is true. Therefore I say to thee, be wary and cold at heart, whatsoever outward semblance thou mayst make. If thou have to yield thee to her, then yield rather late than early, so as to gain time. Yet not so late as to seem 74 shamed in vielding for fear's sake. Bold fast to thy life, my friend, for in warding that, thou wardest me from grief without remedy. Thou wilt see me ere long: it may be to-morrow, it may be some days hence. But forget not, that what I may do, that I am doing. Take heed also that thou pay no more heed tome. or rather less, than if thou wert meeting a maiden of no account in the streets of thine own town. O my love | barren is this first farewell. as was our first meeting: but surely shall there be another meeting better than the first. & the last farewell may be long and long vet. E Therewith she stood up. & he knelt before her a little while without any word, & then arose and went his ways; but when he had gone a space he turned about, and saw her still standing in the same place; shestaved a moment when she saw him turn, and then herself turned about. So he departed through the fair land, and his heart was full with hope & fear as he went.

Now they part for a while

OChapter XI. **Walter happeneth on the** Mistress 政政

T was but a little after noon when Malter left the Maid behind: he steered south by the sun, as the Maid had bidden him, & went swiftly: for, as a

good knight wending to battle, the time seemed long to him till he should meet the foe.

O an hour before sunset he saw something white & gay gleaming through the boles of the oak/trees, & presently there was clear before him a most goodly house build/ ed of white marble, carved all about with knots and imagery, and the carven folk were all painted of their lively colours, whether it were their raiment or their flesh, and the housings wherein they stood all done with gold and fair hues. Gay were the windows of the house; & there was a pillared porch before the great door, with images betwixt the pil/ lars both of men and beasts: and when

Malter looked up to the roof of the Malter house, he saw that it gleamed & shone; cometh for all the tiles were of yellow metal. into the which he deemed to be of verv cold.

LL this he saw as he went, and tarried not to gaze upon it; for he said, belike there will be time for me to look on all this before I die. But he said also, that, though the house was not of the greatest. it was beyond compare of all houses of the world.

Southeenteredit by the porch,& came into a ball many pillared, & vaulted over, the walls paint, ed with gold and ultramarine, the floor dark, and spangled with many colours, and the windows glazed with knots & pictures. Midmost thereof was a foun, tain of gold, whence the water ran two ways in gold/lined runnels, spanned twice with little bridges of silver. Long was that hall, and now not very light, so that Malter was come past the foun, tain before he saw any folk therein: then he looked up toward the high/seat. and him/seemed that a great light shone thence. & dazzled his eves: & he went 77

Ball

There sit twoon the high/seat

on a little way, & then fell on his knees: for there before him on the high/seat sat that wondrous Lady, whose lively image had been shown to him thrice ber fore: and she was clad in gold & jewels. as he had erst seen her. But now she was not alone: for by her side sat a young man, goodly enough, so far as Walter might see him. & most richly clad. with a jewelled sword by his side. & a chaplet of gems on his head. They held each other by the hand, and seemed to be in dear converse together: but they spake softly, so that Malter might not hear what they said, till at last the man spake aloud to the Lady: Seest thou not that there is a man in the hall? B Vea. she said. I see him vonder, kneeling on his knees; let him comenigher & give some account of himself. @So Malterstood up and drew nigh, and stood there, all shamefaced and confused. looking on those twain. & wondering at the beauty of the Lady. Hs for the man. who was slim, and black / haired, and straightfeatured, for all his goodliness Walter accounted him little, & nowise deemed 78

him to look chieftain/like.

Southe Lady spake not to Mal- shamed teranymore than erst: but at last the man said: Thy doest thou not kneel as thou didst erewhile? Malter was on the point of giving him backafierceanswer; but the Lady spake and said: Nav, friend, it matters not whether he kneel or stand; but he may sav.if he will, what he would have of me. & wherefore he is come hither F Then spake Malter. for as wroth & ashamed as he was: Lady, I have straved into this land. & have come to thine house as I suppose. and if I be not welcome. I may well depart straightway, & seek a way out of thy land, if thou wouldst drive me thence, as well as out of thine house B Thereat the Lady turned and looked on him. and when her eves met his, he felt a pang of fear and desire mingled shoot through his heart. This timeshespoketo him: but coldly.with, out either wrath or any thought of him: New/comer, she said. I have not bidden thee hither; but here mayst thou abide a while if thou wilt: nevertheless. take

79

Malter is

The disdain of the Lady

heed that here is no King's Court. There is.forsooth.a folk that serveth me (or. it may be, more than one), of whom thou wert best to know nought. Of others I have but two servants, whom thou wilt see: & the one is a strange creature.who should scare thee or scathe thee with a good will, but of a good will shall serve nought save me; the other is a woman. a thrall. of little avail. save that, being compelled.she will work woman's ser, vice for me, but whom none else shall compel.... Vea, but what is all this to thee: or to me that I should tell it thee? I will not drive thee away; but if thine entertainment please thee not, make no plaint thereof to me, but depart at thy will. Now is this talk betwirt us overlong, since, as thou seest, I & this King's Son are in converse together. Hrt thou a King's Son? KNay, Lady, said Malter. I am but of the sons of the merchants @ It matters not. she said: go thy ways into one of the cham, bers. BAnd straightway she fell a talk ing to the man who sat beside her con cerning the singing of the birds be-80

neath her window in the morning; and None to of how she had bathed her that day in a pool of the woodlands, when she had been heated with hunting. & so forth: and all as if there had been none there save her and the King's Son.

Malter departed all ashamed, as though he had been a poor

man thrust away from a rich kins, man's door: & he said to himself that this woman was hateful, and nought love, worthy. & that she was little like to tempt him. despite all the fairness of her body.

Solo one else he saw in the house that even: he found meat and drink duly served on a fair table. and thereafter he came on a goodly bed. & all things needful, but no child of Adam to do him service. or bid him welcome or warning. Nevertheless he ate, and drank, and slept, and put off thought of all these things till the more row, all the more as he hoped to see the kind maiden some time betwirt sunrise and sunset on that new day.

welcome the quest

g

Chapter XII. The wearing of four days in the Mood beyond the Morld 2 13

E arose betimes, but found no one to greet him, neither was there any sound of folk moving within the fair house; so he but broke his fast,

and then went forth and wandered amongst the trees, till be found him a stream to bathe in, and after be had washed the night off him be lay down under a tree thereby for a while, but soon turned back toward the house, lest perchance the Maid should come thither and be should miss her.

C should be said that half a bow/ shot from the house on that side (i.e. due north thereof) was a lit/ tle hazel/brake, and round about it the trees were smaller of kind than the oaks and chestnuts he had passed through before, being mostly of birch & quick/ en/beam and young ash, with small wood betwixt them; so now he passed through the thicket, and, coming to the

edge thereof, beheld the Lady and the Malter King's Son walking together hand in sees the hand, full lovingly by seeming E he Evil deemed it unmeet to draw back & hide Thing him, so he went forth past them to - again, or ward the house. The King's Son scowl ed on him as he passed, but the Lady. over whose beauteous face flickered the iovous morning smiles. took no more heed of him than if he had been one of the trees of the wood. But she had been so high and disdainful with him the evening before, that he thought little of that. The twain went on, skirting the hazel/copse, and he could not choose but turn his eves on them. so sorely did the Lady's beauty draw them. Then ber fell another thing: for behind them the boughs of the hazels parted, and there stood that little evil thing, he or anoth, er of his kind: for he was quite unclad, save by his fell of yellowy brown hair, and that he was girt with a leathern girdle.wherein was stuck an ugly two edged knife: he stood upright a moment, and cast his eves at Walter & grinned. but not as if he knew him : and scarce 83

onelike him

g2

Malter longeth for the Maíd could Maiter say whether it were the one he had seen. or another: then he cast himself down on his belly, and fell to creeping through the long grass like a serpent, following the footsteps of the Lady and her lover: and now, as he crept, Malter deemed, in his loathing. that the creature was liker to a ferret than aught else. De crept on marvellous swiftly, and was soon clean out of sight. But Malter stood staring after him for a while, and then lay down by the copserside, that he might watch the house and the entry thereof; for he thought, now perchance presently will the kind maiden come bither to comfort me with a word or two. But hour passed by hour, and still she came not: and still he lay there, and thought of the Maid, and longed for her kindness & wisdom. till be could not refrain his tears, & wept for the lack of her. Then he arose, and went and sat in the porch, and was very downcast of mood.

AT as he sat there, back comes the Lady again, the King's Son leading her by the hand; they

entered the porch, and she passed by him so close that the odour of her raiment filled all the air about him, and the sleekness of her side nigh touched him, so that he could not fail to note that her garments were somewhat dis, arrayed, & that she kept her right hand (for her left the King's Son held) to her bosom to hold the cloth together there, whereas the rich raiment had been torn off from her right shoulder. As they passed by him, the King's Son once more scowled on him, wordless, but even more fiercely than before; and again the Lady beeded him nought.

fCER they had gone on a while, be entered the ball, and found it empty from end to end, and no sound in it save the tinkling of the fountain; but there was victual set on the board. Be ate & drank thereof to keep life lusty within bim, & then went out again to the wood-side to watch and to long; and the time bung beavy on his bands because of the lack of the fair Maiden.

Those two pass him disdainfully

The King's Son dríves hím ín

SE was of mind not to go into the house to his rest that night, but to sleep under the boughs of the forest. But a little after sunset he saw a bright/clad image moving amidst the carven images of the porch, and the King's Son came forth & went straight to him, and said: Thou art to enter the house, and go into thy cham, ber forthwith, and by no means to go forth of it betwixt sunset and sunrise. My Lady will not away with thy prowl ing round the house in the night, tide B Therewith he turned away. & went into the house again; and Malter followed him soberly, remembering how the Maid had bidden him forbear. So he went to his chamber, and slept. **WARUT** amidstof the night be a woke and deemed that he heard a voice not far off, so he crept out of his bed & peered around, lest, perchance. the Maid had come to speak with him ; but his chamber was dusk and empty: then be went to the window and looked out, and saw the moon shining bright and white upon the greensward. And 86

lof the Lady walking with the King's H fair Son, & he clad in thin and wanton rai- sight, but ment, but she in nought else save what perilous God had given her of long. crispy vellow hair. Then was Malter ashamed to look on her.seeing that there was a man with her, and gat him back to his bed: but vet a long while ere he slept again he had the image before his eves of the fair woman on the dewy moonlit grass. DE next day matters went much

the same way, and the next also, save that his sorrow was increas, ed. and he sickened sorely of hope der ferred. On the fourth day also the fore, noon wore as erst: but in the heat of the afternoon Malter sought to the hazel copse, and laid him down there hard by a little clearing thereof, and slept from very weariness of grief. There. after a while. he woke with words still hanging in his ears. & he knew at once that it was they twain talking together. The King's Son had just done his say, and now it was the Lady beginning in her honev/sweet voice.lowbut strong. wherein even was a little of huskiness: 87

Kíng's Son

The Lady she said : Otto. belike it were well to mocks the have a little patience, till we find out what the man is. & whence he cometh: it will always be easy to rid us of him: it is but a word to our Dwarf/king.& it will be done in a few minutes B Datience! said the King's Son. angrily: I wot not how to have patience with him; for I can see of him that he is rude and violent and headstrong. & a low/born wily one. forsooth, he had patience en, ough with me the other even, when I rated him in, like the dog that he is, & he had no manhood to sav one word to me. Soothly. as he followed after me. I had a mind to turn about & deal him a buffet on the face, to see if I could but draw one angry word from him, BThe Lady laughed, and said: Well. Otto. I know not: that which thou deemest dastardy in him may be but prudence and wisdom, and he an alien, far from his friends and nigh to his foes. Derchance we shall vet try him what he is. Meanwhile, I rede thee try him not with buffets, save he be weaponless & with bounden hands: or else I deem that but 88

a little while shalt thou be fain of thy The Lady blow.

Outwhen Malter heard her words more and the voice wherein they were friendly said, he might not forbear being stirred by them, and to him, all lonely there. they seemed friendly But he lay still, and the King's Son answered the Lady and said: I know not what is in thine heart concerning this runagate, that thou shouldst bemock me with his valiancy, whereof thou knowest nought. If thou deem me unworthy of thee. send me back safe to my father's country: I may look to have worship there; yea, and the love of fair women belike J Therewith it seemed as if he had put forth his hand to the Lar dy to caress her, for she said : Nay, lay not thine hand on my shoulder. for to, day and now it is not the hand of love. but of pride & folly, and would be masi tery. Nay, neither shalt thou rise up & leave me until thy mood is softer and kinder to me.

Che Lady seems more friendly

And yet again

DEN was there silence betwixt them a while, and thereafter the King's Son spake in a wheedlingvoice: My goddess. I pray thee par don mel But canst thou wonder that I fear thy wearving of me. and am there, fore peevish and jealous? thou so far above the Queens of the Morld. and I a poor youth that without thee were nor thing ! @ She answered nought, and be went on again: Mas it not so, O goddess, that this man of the sons of the merchants was little heedful of thee. and thy loveliness & thy majesty? She laughed & said: Maybe he deemed not that he had much to gain of us, seer ing thee sitting by our side, and where, as we spake to him coldly and sternly & disdainfully. Mithal. the poor youth was dazzled and shamefaced before us: that we could see in the eves and the mien of him.

out this she spoke so kindly & sweetly, that again was Malter all stirred thereat; and it came into his mind that it might be she knew he was anigh and hearing her, and that

she spake as much for him as for the The King's Son: but that one answered: King's Lady, didst thou not see somewhat Son else in his eyes, to wit, that they had would but of late looked on some fair woman other than thee? As for me. I deem it not so unlike that on the way to thine hall be may have fallen in with thy Maid Be spoke in a faltering voice, as if shrinking from some storm that might come. And forsooth the Lady's voice was changed as she answered, though there was no outward heat in it: rather it was sharp and eager and cold at once. She said: Yea, that is not ill thought of: but we may not always keep our thrall in mind. If it besoas thou deem, est, we shall come to know it most like when we next fall in with her: or if she hath been shy this time. then shall she pay the heavier for it: for we will ques, tion her by the fountain in the Ball as to what betid by the fountain of the Rock @Spake the King's Son. faltering vet more: Lady. were it not better to question the man himself? the Maid is stout/hearted, & will not be speedily

draw wrath on the Maid

threatens theMaid

The Lady quelled into a true tale; whereas the man I deem of no account @No. no. said the Lady sharply, it shall not be B Then was she silent a while: & then shesaid: howif theman should prove to be our master? B Nay, our Lady. said the King's Son, thou art jesting with me; thou and thy might and thy wisdom, and all that thy wisdom may command, to be over/mastered by a gangrel churll, But how if I will not have it command, King's Son? said the Lady: I tell thee I know thine heart. but thou knowest not mine. But be at peacel for since thou hast praved for this woman...nay. not with thy words. I wot, but with thy trembling hands.& thineanxious eves. and knitted brow... I say, since thou hast praved for her so earnestly, she shall escape this time. But whether it will be to her gain in the long run. I misdoubt me. See thou to that, Ottol thou who hast held me in thine arms sooft. Hnd now thou may, est depart if thou wilt.

seemed to Malter as if the Thenext dav King's Son were dumbfounder ed at her words: he answered nought.and presently herose from the ground, and went his ways slowly toward the house. The Lady lay there a little while, & then went her ways also: but turned away from the house toward the wood at the other end thereof. whereby Malter had first come thither. S for Malter, he was confused in mind and shaken in spirit; and withal he seemed to see guile & crueldeeds under the talk of those two. and waxed wrathful thereat. Vet he said to himself. that nought might he do. but was as one bound hand and foot. till be had seen the Maid again. Chapter XIII. Now is the hunt up 🕸

EXT morning was he up betimes, but he was cast down and heavy of heart, not looking for aught else to betide than had be tid those last four days.

ut otherwise it fellout; for when he

The Lady is grown gracious to Malter came down into the hall, there was the Lady sitting on the high/seat all alone. clad but in a coat of white linen : & she turned her head when she heard his footsteps. & looked on him. & areeted him. and said: Come hither. quest. So he went and stood before her. and she said: Though as yet thou has thad no welcome here. & no honour, it hath not entered into thine heart to flee from us: and to say sooth. that is well for thee, for flee away from our hand thou mightest not. nor mightest thou depart without our furtherance. But for this we can thee thank, that thou hast abided here our bidding, & eaten thine heart through the heavy wearing offour davs. and made no plaint. Vet I cannot deem thee a dastard: thou so well knit and shapely of body, so clear/eyed and bold of visage. Mherefore now I ask thee. art thou willing to do me service. thereby to earn thy questing?

HLTERansweredher, somer what faltering at first, for he was astonished at the change which had come over her; for now she

spoke to him in friendly wise, though She bidindeed as a great lady would speak to a deth him voung man ready to serve her in all ho, service nour. Said he: Lady. I can thee thank humbly and heartily in that thou biddest me do thee service: for these days past I have loathed the emptiness of the hours, and nought better could I ask for than to serve so glorious a Mis, tress in all honour J She frowned somewhat, and said: Thou shalt not call me Mistress: there is but one who so calleth me, that is my thrall: & thou artnone such. Thou shalt call me Lady. and I shall be well pleased that thou be my squire, and for this present thou shalt serve me in the hunting. So get thy gear: take thy bow and arrows, and gird thee to thy sword. for in this fair land may one find beasts more perilous than be buck or hart. I go now to array me: we will depart while the day is yet voung: for so make we the summer day the fairest.

E made obeisance to her, and she arose & went to her chamber, and Malter dight himself, and then

Now cometh the Maid again abode her in the porch; and in less than an hour she came out of the hall, and Walter's heart beat when he saw that the Maid followed her hard at heel, and scarce might he school his eyes not to gaze over/eagerly at his dear friend. She was clad even as she was before, and was changed in no wise, save that love troubled her face when she first be/ held him, & she had much ado to master it: howbeit the Mistress heeded not the trouble of her, or made no semblance of heeding it, till the Maiden's face was all according to its wont.

This Malter found strange, that after all that disdain of the Maid's thralldom which he had heard of the Mistress, and after all the threats against her, now was the Mistress become mild and debonaire to her, as a good lady to her good maiden. Mhen Malter bowed the knee to her, she turned unto the Maid, and said: Look thou, my Maid, at this fair new Squire that I have gotten 1 Mill not he be valiant in the greenwood? And see whether he be well shapen or not. Doth

he not touch thine heart, when thou The Lady thinkest of all the woe, and fear, and is kind trouble of the Morld beyond the Mood, which he hath escaped, to dwell in this little land peaceably, and well/beloved both by the Mistress & the Maid? And thou, my Squire, look a little at this fair slim Maiden, and say if she pleaseth thee not: didst thou deem that we had any thing so fair in this lonely place?

RÄNK and kind was the smile on her radiant visage, nor did she seem to note any whit the trouble on Malter's face, nor how he strove to keep his eves from the Maid. Hs for her.she had so wholly mastered her countenance. that belike she used her face quilefully, for she stood as one humble but happy, with a smile on her face, blushing, and with her head hung down as if shamefaced before a goodly young man. a stranger, But theLady looked upon herkindly & said: Come hither, child, and fear not this frank and free young man, who belike feareth theea little. & full certainly fear, eth me; and yet only after the manner h 97

H lovely thing in the land of men B And therewith she took the Maid by the hand and drew her to her. & pressed her to her bosom. & kissed her cheeks and her lips, and undid the lacing of her gown & bared a shoulder of her, and swept away her skirt from ber feet: and then turned to Walter and said: Lo thou. Squire 1 is not this a lovely thing to have grown up amongst our rough oak, boles? What 1 art thou looking at the iron ring there? It is nought. save a token that she is mine. and that I may not be without her. Then she took the Maid by the shoulders and turned her about as in sport. and said: Go thou now, & bring hither the good grey ones: for needs must we bring home some venison to day, where, as this stout warrior may not feed on nought save manchets and honey.

O the Maid went her way, taking care, as Walter deemed, to give no side glance to him. But he stood there shamefaced, so confused with all this open/hearted kindness of the great Lady & with the fresh sight of the darling beauty of the Maid, that 08

The Lady bewent nigh to thinking that all he had heard since he had come to the porch of the house that first time was but a dream of evil.

unit while he stood pondering these matters, and staring beforehimas one mazed. the Lady laughed out in his face, and touched him on the arm& said: Hh. our Squire. is it so that now thou hast seen my Maid thou wouldst with a good will abide behind to talk with her? But call to mind thy word pledged to me e'en now! And moreover I tell thee this for thy behoof now she isout of ear/shot. that I will above all things take thee

away torday: for there be other eyes. & they nought uncomely, that look at whiles on my fair/ankled thrall: & who knows but the swords might be out if I take not the better heed, and give thee not every whit of thy will.

S she spoke and moved forward, be turned a little, so that now the edge of that hazel coppice was within his evershot. & he deemed that oncemore he saw the vellow/brown evil

h 2

99

iests bit-

ter/sweet

Malter meets guile with guile

thing crawling forth from the thicket; then, turning suddenly on the Lady, hemether eyes, and seemed in one morment of time to find a far other look in them than that of frankness and kindness; though in a flash they changed back again, and she said merrily and sweetly: So so, Sir Squire, now art thou awake again, & mayest for a little while look on me.

South it came into his head, with that look of hers. all that might befall him and the Maid if he mastered not his passion, nor did what he might to dissemble: so he bent the knee to her, and spoke boldly to her in ber own vein, and said: Nay, most gracious of ladies. never would I abide ber hind to, day since thou farest afield. But if my speech be hampered, or mine eves stray, is it not because my mind is confused by thy beauty. & the boney of kind words which floweth from thy mouth? She laughed outright at his word. but not disdainfully, and said: This is well spoken, Squire, and even what a souire should say to his liege 100

lady, when the sun is up on a fair morn, Of the ing, and she and he and all the world Lady's are glad B She stood quite near him as array she spoke, her hand was on his should der, and her eves shone and sparkled. Sooth to say, that excusing of his confusion was like enough in seeming to the truth: for sure never creature was fashioned fairer than she: clad she was for the greenwood as the hunting god, dess of the Gentiles, with her green gown gathered unto her girdle, & sandals on her feet: a bow in her hand and a quiver at her back: she was taller and bigger of fashion than the dear Maiden. whiter of flesh, and more glorious, and brighter of hair: as a flower of flowers for fairness and fragrance.

The said: Thou art verily a fair squire before the hunt is up, & if thou be as good in the hunting, all will be better than well, and the quest will be welcome. But lo1 here cometh our Maid with the good grey ones. Go meet her, and we will tarry no longer than for thy taking the leash in hand So Walter looked, and saw the

The Lady lies somer what Maid coming with two couple of great bounds in the leash straining against her as she came along. He ran lightly to meet her, wondering if he should have a look, or a half, whisper from her: but she let him take the white thongs from her hand, with the same halfsmile of shamefacedness still set on herface. &. going past him.camesoftly up to the Lady, swaying like a willowbranch in the wind, and stood before her, with her arms hanging down by hersides. Then the Lady turned to her. and said: Look to thyself, our Maid, while we are away. This fair young man thou needest not to fear indeed. for he is good and leal: but what thou shalt do with the King's Son I wot not. he is a hot lover forsooth.but a hard man: and whiles evil is his mood, & perilous both to thee and me. And if thoudohis will.it shall be ill for thee: & if thou do it not. take beed of him. and let me. and me only. come between his wrath and thee.Imay do somewhat for thee. Even vesterday he was instant with me to have the chastised after the manner of

thralls: but I bade him keep silence of Nowis the such words, and jeered him & mocked Maid left him, till be went away from me peevish behind & in anger. So look to it that thou fall not into any trap of his contrivance.

DEN the Maidcast herself at the Mistress's feet, & kissed & em-braced them; and as she rose up, the Lady laid her hand lightly on her head. and then. turning to Malter. cried out: Now Squire, let us leave all these troubles and wiles and desires behind us, and flit through the merry greenwood like the Gentiles of old days. And therewith she drew up the laps of her gown till the whiteness of herknees was seen, and set off swiftly toward the wood that lay south of the house. and Walter followed. marvelling at ber goodliness; nor durst he cast a look backward to the Maiden. for he knew that she desired him. & it was her only that he looked to for his deliverance from this house of quile and lies.

bapter XI

V. The Bunting of the Bart.

done for that time.

O the Lady cast herself down on the green grass anigh the water,

while Malter blew the hounds in and coupled them up: then he turned round to her, & loi she was weeping for despite that they had lost the quarry: and again did Malter wonder that so little a matter should raise a passion of tears in her. he durst not ask what ailed her. or proffer her solace, but was not ill apaid by beholding her loveliness as there she lay.

RESENCLYsheraisedupher head and turned to Malter, and spake to him angrily and said: Squire, why dost thou stand staring at me like a fool? JE Yea, Lady, he said: but the sight of thee maketh me foolish to do aught else but to look on thee Bhe said, in a peevish voice: Tush. Squire.theday is too far spent for soft and courtly speeches: what was good there is nought so good here. Mithal, I know more of thine heart than thou deemest. BMalterhungdown his head and reddened, and she looked on him.

105

The Lady is peevish

The Lady will bathe

and her face changed, and she smiled & said, kindly this time: Look ye, Squire, I am hot and weary, and ill/content; but presently it will be better with me; for my knees have been telling my shoulders that the cold water of this little lake will be sweet & pleasant this sum/ mer noonday, and that I shall forget my foil when I have taken my pleasure therein. Alberefore, go thou with thine hounds without the thicket and there abide my coming. And I bid thee look not aback as thou goest, for therein were peril to thee: I shall not keep thee tarrying long alone.

E bowed his head to her, and turned and went his ways. And now, when he was a little space away from her, he deemed her indeed a marvel of women, and wellnigh forgat all his doubts & fears concerning her, whether she were a fair image fashion, ed out of lies and guile, or it might be but an evilthing in the shape of a good, ly woman. forsooth, when he saw her caressing the dear and friendly Maid, his heart all turned against her, despite 106 what his eves & his ears told his mind. Now is & she seemed like as it were a serpent she kind enfolding the simplicity of the body again which he loved , But now it was all changed, and he lay on the grass and longed for her coming : which was der laved for somewhat more than an hour. Then she came back to him. smiling & fresh and cheerful, her green gown let down to her heels @ he sprang up to meet her. & she came close to him. and spake from a laughing face: Squire, hast thou no meat in thy wallet? for. meseemeth. I fed thee when thou wert hungry the other day: do thou now the same by me J he smiled, and louted to her, and took his wallet and brought out thence bread and flesh and wine. & spread them all out before her on the green grass, and then stood by humbly before her. But she said: Nay, my Squire, sit down by me & eat with me, for to/day are we both hunters together B So he sat down by her trembling, but neither for awe of her greatness, nor for fear & horror of her quile and sorcerv.

She asks Malter of Langton and its folk

MAILE they sat there together after they had done their meat, & the Lady fell a talking with Wal ter concerning the parts of the earth, and the manners of men, & of his jour, nevings to and fro, #Ht last she said: Thou hast told me much and answered all my questions wisely, and as my good Squire should, and that pleaseth me. But now tell me of the city wherein thou wert born & bred : a city whereof thou hast hitherto told me nought B Lady, he said, it is a fair and a great city. & to many it seemeth lovely. But I have left it. and now it is nothing to me J Dast thou not kindred there? said she P Yea, said he, and foemen withal: and a false woman wavlayeth my life there I And what was she? said the Lady @ Said Walter: She was but my wife JF Mas she fair? said the Lady @ Malter looked on her a while, and then said: I was going to say that she was well-nigh as fair as thou; but that may scarce be. Vet was she very fair. But now, kind and gracious Lady, I will sav this word to thee: I marvel 108

that thou askest so many things con- Malter cerning the city of Langton on Bolm. tellethher where I was born, and where are my of his kindred yet; for meseemeth that thou vision knowest it thyself #Iknow it. I? said the Lady Bathat, then 1 thou knowest it not?said Malter Spake the Lady, and some of her old disdain was in her words: Dost thou deem that I wander about the world & its cheaping steads like one of the chapmen? Nay, I dwell in the Mood beyond the Morld, & nowhere else. That hath put this word into thy mouth? B he said : Dardon me. Lady. if I have misdone: but thus it was: Mine own eves beheld thee going down the guays of our city, and thence a ship/board. & the ship sailed out of the baven. And first of all went a strange dwarf.whom I have seen here. and then thy Maid; and then went thy gracious and lovely body.

DE Lady's face changed as he spoke, and she turned red and then pale. & set her teeth; but she refrained her. & said: Squire. I see

of thee that thou art no liar, nor light 100

The Lady of wit, therefore I suppose that thou is wroth hast verily seen some appearance of

me; but never have I been in Langton, nor thought thereof, nor known that such a stead there was until thou namedst it e'en now. Wherefore, I deem that an enemy bath cast the shadow of me on the air of that land *Y*ea, my Lady, said Walter; and what enemy mightest thou have to have done this? *She was slow of answer, but spake* at last from a quivering mouth of anger: Knowest thou not the saw, that a man's foes are they of his own house? If I find out for a truth who hath done this, the said enemy shall have an evil hour with me.

GHIN she was silent, and she clenched her hands & strained her limbs in the heat of her an, ger; so that Walter was afraid of her, and all his misgivings came back to his heart again, & he repented that he had told her so much. But in a little while all that trouble and wrath seemed to flow off her, and again was she of good cheer, and kind and sweet to him; and

she said: But in sooth, however it may Now is be, I thank thee, my Squire and friend. She kind for telling me hereof. And surely no again wyte do I lay on thee. And, moreover, is it not this vision which hath brought thee hither? Bo it is. Lady. said he B Then have we to thank it, said the Lady. & thou art welcome to our land BAnd therewith she held out her hand to him, and he took it on his knees and kissed it: & then it was as if a red/bot iron had run through his heart. and he felt faint. & bowed down his head. But he held her hand vet. & kissed it many times, and the wrist and the arm, and knew not where he was.

BAUT she drew a little away from him, and arose and said : Now is Athe day wearing, and if we are to bear back any venison we must buckle to the work. So arise, Squire, and take the hounds and come with me: for not far off is a little thicket which mostly harbours foison of deer, great & small. Let us come our ways.

hapter XV. The slaving of the Quarry O they walked on quietly thence some half a mile. and ever the Lady would have Malter to walk by her side. & not follow a little behind her, as was

meet for a servant to do: & she touch ed his hand at whiles as she showed him beast and fowl and tree. and the sweetness of her body overcame him, so that for a while he thought of nothing save her.

Sou when they were come to the thicket/side, she turned to him & said : Squire, I am no ill wood man. so that thou mayst trust methat we shall not be brought to shame the second time: and I shall do sagely: so nock an arrow to thy bow, and abideme here. & stir not hence: for I shall enter this thicket without the bounds, and arouse the guarry for thee; and see that thou be brisk and clean/shooting, and then shalt thou have a reward of me. E Therewith she drew up her skirts through her girdle again, took her bent 112

bowin her hand, and drew an arrow out New of the quiver, and stepped lightly in, tidings to the thicket, leaving him longing for the sight of her, as he hearkened to the tread of her feet on the dry leaves, and the rustling of the brake as she thrust through it *P* Thus he stood for a few minutes, and then he heard a kind of gibbering cry without words, yet as of a woman, coming from the thicket, & while his heart was yet gathering the thought that something had gone amiss, he glided swiftly, but with little stir, into the brake.

E had gone but a little way ere be saw the Lady standing there in a narrow clearing, her face pale as death, her knees cleaving together, her body swaying and tottering, her bands hanging down, and the bow and arrow fallen to the ground; and ten yards before her a great/headed yellow creature crouching flat to the earth and slowly drawing nigher **D** he stopped short; one arrow was already notched to the string, & another hung loose to the lesser fingers of his string/

1

The lion slain

band. Be raised his right hand. & drew & loosed in a twinkling: the shaft flew close to the Lady's side, and straightway all the wood rung with a hugeroar. as the vellow lion turned about to bite at the shaft which had sunk deep into him behind the shoulder. as if a bolt out of the beavens had smitten him. But straightway had Malter loosed as gain. & then, throwing down his bow. he ran forward with his drawn sword gleaming in his hand, while the lion weltered and rolled, but had no might to move forward. Then Malter went up to him warily & thrust him through to the heart, & leapt aback, lest the beast might vet have life in him to smite; but he left his struggling, his huge voice died out. and he lav there moveless ber fore the hunter.

ALCER abode a little, facing bim, & then turned about to the Lady, and she had fallen down in a heap whereas she stood, and lay there all huddled up and voiceless. So he knelt down by her, and lifted up her head, and bade her arise, for the foe

wasslain. Andafteralittleshestretch, The lady edouther limbs, & turned about on the fleeth the grass, & seemed to sleep, and the col- field of our came into her face again, & it grew deed soft and a little smiling. Thus she lay awhile, and Walter sat by her watching her. till at last she opened her eyes and sat up, and knew him, and smiling on him said: What hath befallen, Squire, that I have slept & dreamed? B he and swered nothing, till her memory came back to her, and then she arose, trembling and pale, & said: Let us leave this wood. for the Enemy is therein BAnd she hastened away before him till they came out at the thicket, side whereas the bounds had been left, & they were standing there uneasy and whining; so Malter coupled them. while the Ladv staved not. but went away swiftly homeward, and Walter followed.

Clast she stayed her swift feet, and turned round on Malter, and said: Squire, come hither 1 9 So did he, and she said: I am weary again; let us sit under this quicken/tree, and rest us So they sat down, and she

í 2

Now she cometh to herself sat looking between her knees a while: and at last she said: Thy didst thou not bring the lion's hide? @ he said: Lady, I will go back and flay the beast. and bring on the hide B And he arose therewith, but she caught him by the skirts and drew him down, and said: Nay, thou shalt not go; abide with me. Sit down again J he did so, and she said: Thou shalt not go from me; for I am afraid: I am not used to looking on the face of death B She grew pale as she spoke. & set a hand to her breast. & sat so a while without speaking. Ht last she turned to him smiling. & said: how was it with the aspect of mewhen Istood before the peril of the Enemy? # And she laid a hand upon his @ O gracious one, quoth he, thou wert, as ever, full lovely, but I feared for thee She moved not her hand from his. and she said: Good and true Squire. I said ere I entered the thicket e'en now that I would reward thee if thou slewest the quarry. he is dead, though thou hast left theskin behind upon the carcase. Asknow thy reward, but take time 116

to think what it shall be B he felt her H reward hand warm upon his, and drew in the sweet odour of her mingled with the woodland scents under the bot sun of the afternoon. & his heart was clouded with manlike desire of ber. And it was a near thing but he had spoken, and craved of her the reward of the freedom of her Maid, and that he might depart with her into other lands: but as his mind wavered betwixt this & that. the Lady, who had been eyeing him keenly, drew her hand away from him : & there, with doubt & fear flowed into his mind. & he refrained him of speech. E Then she laughed merrily & said: The good Squireisshamefaced: he fearethalady more than a lion. Mill it be a reward to thee if I bid thee to kiss my cheek? Therewith she leaned her face toward him. and he kissed her well favouredly, and then sat gazing on her, wondering what should betide to him on the morrow.

DEN she arose & said: Come Squire, and let us home: benot abashed. there shall be other

117

of valiancv

rewards hereafter, **#** Sothey went their ways quietly; and it was nigh sunset against they entered the house again. Walter looked round for the Maid, but beheld her not; & the Lady said to him: I go to my chamber, & now is thy service over for this day, **#** Then she nodded to him friendly and went her ways. Chapter XVI. Of the King's Son & the Maid, #

as for Malter, he went out of the house again, and fared slowly over the woodlawns till be came to another close thicket or brake; he entered from

mere wantonness, or that he might be the moreapart & hidden, so as to think over his case. There he lay down under the thick boughs, but could not so herd his thoughts that they would dwell steady in looking intowhat might come to him within the next days; rather visions of those two women & the monster did but float before him, and fear and desire & the hope of life ran to and fro in his mind.

S he lay thus he heard footsteps drawing near, and he looked be-tween the boughs, and though thesun had just set, he could see close by him a man & a woman going slowly. & they hand in hand : at first he deemed it would be the King's Son & the Lady. but presently he saw that it was the King's Son indeed, but that it was the Maid whom he was holding by the hand. And now he saw of him that his eves were bright with desire. and of her that she was very pale. Yet when he heard her begin to speak, it was in a steady voice that she said: # King's Son. thou hast threatened me oft and unkindly, and now thou threatenest me again, and no less unkindly. But whatever were thy need herein before, now is there no more need; for my Mistress. of whom thou wert weary, is now grown weary of thee. & belike will not now reward me for drawing thy love to me, as onceshe would have done: to wit. before the coming of this stranger. Therefore I sav, since I am but a thrall, poor and

Kíng's Son

and the

The Maid

Malter noteth the spy

helpless, betwixt you two mighty ones, I have no choice but to do thy will **B** Hs she spoke she looked all round about her, as one distraught by the anguish of fear. Walter, amidst of his wrath and grief, had well/nigh drawn his sword & rushed out of his lair upon the King's Son. But he deemed it sure that, so doing, he should undo the Maid altogether, and himself also belike, so he refrained him, though it were a hard matter.

be Maid had stayed herfeet now close to where Walter lay, some five yards from him only, and he doubted whether she saw him not from where she stood. As to the King's Son, he was so intent upon the Maid, and so greedy of her beauty, that it was not like that he saw anything P Now more, over Walter looked, & deemed that he beheld something through the grass and bracken on the other side of those two, an ugly brown and yellow body, which, if it were not some beast of the foumart kind, must needs be the monstrous dwarf, or one of his kin; and the

flesh crept upon Malter's bones with Hn unthe horror of him, But the King's kind lover Son spoke unto the Maid: Sweetling. I shall take the gift thou givest me, neither shall I threaten thee any more, howbeit thou givest it not very gladly or graciously @ She smiled on him with her lips alone. for her eves were wandering and haggard. My lord, she said, is not this the manner of women? I Tell, he said, I sav that I will take thy love even so given. Vet let me hear ar gain that thou lovest not that vilenew, comer. & that thou hast not seen him. save this morning along with my Lady. Nav now, thou shalt swear it @ What shall I swear by? she said @Quoth he. thou shalt swear by my body: & there, withhethrusthimselfcloseupagainst her: but she drew her hand from his. & laid it on his breast, and said: I swear it by thy body B he smiled on her licorously, and took her by the shoulders, and kissed her face many times, & then stood aloof from her, and said: Now have I had hansel: but tell me, when shall I come to thee? She spoke out

Malter & clearly: Mithin three days at furthest; the Maid I will do thee to wit of the day and the

hour to/morrow, or the day after *B* he kissed her once more, and said: forget it not, or the threat holds good *B* And therewith he turned about and went his ways toward the house; & Walter saw the yellow/brown thing creeping after him in the gathering dusk.

S for the Maid, she stood for a while without moving, and SAM looking after the King's Son & the creature that followed him. Then she turned about to where Malter lav and lightly put aside the boughs, and Malter leapt up, and they stood face to face. She said softly but eagerly: friend, touch me not yet! Be spake not, but looked on her sternly. She said: Thou art anory with me? @Still hespakenot: but she said: friend.this at least I will pray thee; not to play with life & death ; with happiness and miserv. Dost thou not remember the oath which we swore each to each but a little while ago? And dost thou deem that I have changed in these few days? Is thy

mind concerning thee and me the same her sweetas it was? If it be not so. now tell me. ness & her for now have I the mind to do as if nei ther thou nor I are changed to each oth, er, whoever may have kissed mine unwilling lips, or whom so ever thy lips may have kissed. But if thou hast changed. and wilt no longer give me thy love.nor crave mine. then shall this steel (& she drew a sharp knife from her girdle) be for the fool and the dastard who hath made thee wroth with me. my friend. & my friend that I deemed I had won. And then let come what will come! But if thou be nought changed, & the oath vet holds, then, when a little while hath passed, may we thrust all evil and guile and grief behind us, and long joy shall lie beforeus, and long life. & all honour in death: if only thou wilt do as I bid thee, Omy dear, and my friend, and my first friend!

E looked on her, and his breast heaved up as all the sweetness of her kind love took hold on him. and his face changed, & the tears filled his eyes and ran over, and rained down

123

valiancv

Malter overcome by love

before her, and he stretched out his hand toward her. # Then she said exceeding sweetly: Now indeed I see that it is well with me, yea, & with thee also. A sore pain it is to me, that not even now may I take thine hand, and cast minearms about thee, and kiss the lips that love me. But so it has to be. My dear. even so I were fain to stand here long before thee, even if we spake no more word to each other; but abiding here is perilous; for there is everan evil spy upon my doings, who has now as I deem followed the King's Son to the house, but who will return when he has tracked him home thither: so we must sunder. But belike there is vet time for a word or two: first, the rede which I had thought on for our deliverance is now afoot. though I durst not tell thee thereof.nor have time thereto. But this much shall I tell thee, that whereas great is the craft of my Mistress in wiz, ardry. vet I also have some little craft therein, and this, which she hath not, to change the aspect of folk soutterly that they seem other than they verily 124

are; yea, so that one may have the aspect She of another. Now the next thing is this: pleads whatsoever my Mistress may bid thee, with do her will therein with no more navsaving than thou deemest may please her. And the next thing: wheresoever thou mayst meet me, speak not to me. makenosian tome.even when Iseem to beallalone, till Istoop down and touch theringon myankle with my right hand: but if I do so, then stay thee, without fail, till I speak. The last thing I will sav to thee. dear friend, ere we both go our wavs. this it is. When we are free. and thou knowest all that I have done. I pray thee deem me not evil & wicked. and be not wroth with me for my deed: whereas thou wottest well that I am not in like plight with other women. I have heard tell that when the knight goeth to the war, and hath overcome his foes by the shearing of swords and guileful tricks, & hath come back home to his own folk, they praise him & bless him, and crown him with flowers, and boast of him before God in the minster for his deliverance of friend and folk

Malter

and city. Thy shouldst thou be worse to me than this? Now is all said, my dear and my friend; farewell, farewell DERECITO she turned & went her ways toward the house in all speed, but making somewhat of a compass. And when she was gone, Talterknelt down and kissed the place where her feet had been, & arose thereafter, & made his way toward the house, he also, but slowly, and staying oft on his way.

Chapter XVII. Of the House and the Dleasance in the Mood A

N the morrow morning Malter loitered a while about the house till the morn was grown old, and then about noon he took his bow and arrows and

went into the woods to the northward, to get him some venison. He went some, what far ere he shot him a fawn, & then he sat him down to rest under the shade of a great chestnut tree, for it was not far past the hottest of the day. He look,

ed around thence and saw below him a The Lady little dale with a pleasant stream run- is here ning through it. and he bethought him of bathing therein, so he went down & had his pleasure of the water and the willowv banks: for he lav naked a while on the grass by the lip of the water. for joy of the flickering shade, and the little breeze that ran over the down/long ripples of the stream @ Then he did on his raiment, and began to come his ways up the bent, but had scarce gone three steps ere he sawa woman coming towards him from down/stream. his beart came into bis mouth when he saw her.for she stooped & reached down her arm, as if she would lay her hand on her ankle. so that at first he deemed it had been the Maid. but at the second eveshot he saw that it was the Mistress. She stood still and looked on him. so that he deemed she would have him cometoher. So he went to meet her, and grew somewhat shamefaced as he drew nigher. & wondered at her. for now was she clad but in one garment of some dark grey silky stuff, embroidered with,

abashed

Walter is as it were. a garland of flowers about the middle. but which was so thin that. as the wind drifted it from side and limb. it hid her nomore, but for the said garland, than if water were running over her: her face was full of smiling jov & content as she spake to him in a kind. caressing voice, and said: I give thee good day, good Squire, & well art thou met. And she beld out her hand to him. Beknelt down before berand kissed it. and abode still upon his knees. & hange ing down his head, But she laughed outright, and stooped down to him, & put her hand to his arms, & raised him up, and said to him: That is this, my Squire, that thou kneelest to me as to an idol? Bhesaid faltering: I wotnot: but perchance thou art an idol; and I fear thee Mati she said. more than vesterday, whenas thou sawest me afraid? @ Said he: Yea, for that now I see thee unhidden. & meseemeth there hath been none such since theold days of the Gentiles, She said: hast thou not vet bethought thee of a gift to crave of me. a reward for the slaving of 128

mineenemy, and the saving of me from The Lady death? @ O my Lady, he said, even so is wrath much would I have done for any other with lady, or, for sooth, for any poor man: for Malter somv manhood would have biddenme. Speak not of gifts to me then. Moreover (and he reddened therewith. & his voice faltered), didst thou not give me my sweetreward vesterday? What more durst Task?

DE held her peace awhile, & look, ed on him keenly; & he reddened under her gaze. Then wrath came into her face, and she reddened & knit her brows, and spake to him in a voice of anger, & said: Nay, what is this? It is growing in my mind that thou deem est the gift of me unworthy [Thou. an alien, an outcast: one endowed with the little wisdom of the Morld without the mood! And here I stand before thee. all glorious in my nakedness. & so fulfilled of wisdom. that I can make this wilderness to any whom I love more full of joy than the kingdoms & cities of the world ... and thou 1 ... Ah, but it is the Enemy that hath done this. & made

k

Malter is careful of his speech the guileless guilefull Yet will I have the upper hand at least, though thou suffer for it, and I suffer for thee.

BALTERstood before her with hanging head, & he put forth bis hands as if praving off her anger, and pondered what answer he should make: for now he feared for him, self and the Maid; so at last he looked up to her, and said boldly: Nay, Lady, I know what thy words mean, whereas I remember thy first welcome of me. I wot. forsooth, that thou wouldst call me base/born, and of no account, and unworthv to touch the hem of thv raiment: and that I have been over/bold. and quilty towards thee: & doubtless this is sooth. and I have deserved thine anger: but I will not ask thee to pardon me. for I have done but what I must needs. She looked on him calmly now. and without any wrath, but rather as if she would read what was written in his inmost heart. Then her face changed into jovousness again, and shesmote her palms together. & cried out: This is but foolish talk; for vesterday did I 130

see thy valiancy, and torday I have seen The Ladv thy goodliness; and I say, that though would be thou mightest not be good enough for friends a fool woman of the earthly baronage, with him

vet art thou good enough for me. the wise and the mighty, & the lovely. And whereas thou savest that I gave thee but disdain when first thou camest to us, grudge not against me therefor, because it was done but to prove thee: and now thou art proven.

DEN again he knelt down before ber, and embraced her knees, and again she raised him up, and let

ber arm hang down over his shoulder. and ber cheek brush his cheek : and she kissed his mouth and said: hereby is all forgiven. both thine offence & mine: and now cometh joy and merry days.

DEREWITh hersmiling face grewgrave, & she stood before

him looking stately & gracious and kind at once. and she took his hand & said: Thou mightest deem my cham, ber in the Golden House of the Mood overqueenly, since thouart no masterful man. So now hast thou chosen well

k 2

in the bool

H garden the place wherein to meet me to/day. for hard by on the other side of the stream is a bower of pleasance, which. forsooth.not every one who cometh to this land may find: there shall I be to thee as one of the up/country damsels of thine own land, and thou shalt not be abashed B She sidled up to him as shespoke, and would be, would benot. her sweet voice tickled his very soul with pleasure, and she looked aside on him happy and well-content.

> O they crossed the stream by the shallow below the pool wherein Malterhad bathed, & within a lit, tle they came upon a tall fence of flakehurdles, and a simple gate therein. The Lady opened the same, and they entered thereby into a close all planted as a most fair garden, with hedges of rose and woodbine, and with linden/trees ablossom, & long ways of green grass betwixt borders of lilies and clovergiliflowers, and other sweet garland/flowers. And a branch of the stream which they had crossed erewhile wandered through that garden: and in the midst

was a little house built of post & pan. H house and thatched with vellow straw. as if it of pleasance were new done.

BEN Malter looked this way and that, & wondered at first, & tried to think in his mind what should come next, and how matters would go with him; but his thought would not dwell steady on any other matter than the beauty of the Lady amidst the beau, tvof the garden: & withal she was now grown so sweet and kind. & even somer what timid & shy with him, that scarce díd he know whose hand he held. or whose fragrant bosom and sleek side went so close to him @ So they wandered here and there through the waning of the day, and when they entered at last into the cool dusk house, then

they loved & played together. as if they were a pair of lovers quileless, with no fear for the morrow. and no seeds of enmity and death sown betwixt them.

Old on the morrow, when Malter was awake, he found there was no one lying beside him, and the day was no longer very young; so he arose, and

went through the garden from end to end, and all about, and there was none there: & albeit that he dreaded to meet the Lady there, yet was he sad at heart & fearful of what might betide. howsoever, he found the gate whereby they had entered vesterday, and he went out into the little dale; but when he had gone a step or two he turned about, & could see neither garden nor fence, nor any sign of what he had seen thereof but lately. He knit his brow and stood still to think of it, & his heart grew the heavier thereby; but presently he went his ways and crossed the stream, but had scarce come up on to the grass on the further side, ere he saw a woman coming to meet him, and at first, full

as he was of the tide of vesterday and The Maid the wondrous garden. deemed that it cometh would be the Lady: but the woman again staved her feet, and, stooping, laid a hand on her right ankle, & he saw that it was the Maid. Be drew anigh to her, and saw that she was nought so sad of countenance as the last time she had methim.butflushed of cheek & bright, eved, #Hs he came up to her she made a step or two to meet him, holding out her two hands, and then refrained her. & said smiling: Ah. friend, belike this shall be the last time that I shall say to thee.touch me not. nav. not somuch as my hand, or if it were but the hem of my raiment OThe joy grewup in his heart, and he gazed on her fondly, and said: Thy, what then hath befallen of late? C friend, she began, this hath befallen. But as he looked on her, the smile died from her face, & she became deadly pale to the very lips; she looked askance to her left side, whereas ran the stream; and Malter followed her eves, and deemed for one instant that he saw the misshapen yellow visage of

She giveth Malter tryst in strange wise

the dwarf peering round from a grey rock. but the next there was nothing. Then the Maid. though she were as pale as death.wenton in a clear.steady.hard voice, wherein was no jov or kindness. keeping her face to Malter & her back to thestream : This hath befallen. friend. that there is no longer any need to refrain thy lovenor mine: therefore I say to thee. come to my chamber (& it is the red chamber over against thine. though thou knewest it not) an hour before this next midnight. & then thy sorrow and mine shall be at an end: and now I must needs depart. followmenot. but remember 1. # And therewith she turned about & fled like the wind down the stream.

RT Calterstood wondering, and knewnot what to make of it, where ther it were for good or ill: for be knewnow that she had paled & been seized with terror because of the upheaving of the ugly head; & yet she had seemed to speak out the very thing she had to say. How so ever it were, he spake aloud to himself: Calhatever comes, I 136

willkeep tryst with her B Then hedrew Malter his sword, and turned this way & that, is not looking all about if he might see any unmerry sian of the Evil Thing: but nought might his eves behold, save the grass. and the stream, and the bushes of the dale. So then. still holding his naked sword in his hand, he clomb the bent out of the dale; for that was the only way he knew to the Golden House: and when became to the top, & the summer breeze blew in his face, and he looked down a fair green slope beset with goodly oaks and chestnuts, he was rer freshed with the life of the earth, and he felt the good sword in his fist, and knew that there was might and longing in him. & the world seemed open unto him Jo be smiled, if it were somewhat grimly, and sheathed his sword and went on toward the house.

Chapter XIX. Malter goes to fetch home the Lion's Hide A

E entered the cool dusk through the porch, and, looking down the pillared hall, saw beyond the fountain a gleam of gold, and when he came past the

said fountain he looked up to the high, seat, and lot the Lady sitting there clad in her queenly raiment. She called to him, and he came: and she hailed him, and spake graciously and calmly, yet as if she knew nought of him save as the leal servant of her, a high Lady. Squire, she said, we have deemed it meet to have the hide of the servant of the Enemy, the lion to wit, whom thou slewest yesterday, for a carpet to our feet; wherefore go now, take thy wood, knife, and flay the beast, and bring me homehisskin. Thisshall beall thyser, vice for this day, so mayst thou do it at thineown leisure, and not weary thy, self. May good gowith thee Bhe bent the knee before her, and she smiled on

himgraciously, but reached out no hand There for him to kiss, and beeded him but little. Mberefore. in spite of himself. and though he knew somewhat of her quile, he could not help marvelling that this should be she who had lain in his arms night/long but of late.

CalSO that might be, he took his way toward the thicket where he had slain the lion, & came thither by then it was afternoon. at the bottest of the day. So he entered therein, and came to the very place whereas the Lady had lain, when she fell down before the terror of the lion: & there was the mark of her body on the grass where she had lain that while. like as it were the form of a bare. But when Malter went on to where he had slain that great beast. lo1 he was gone, and there was no sign of him: but there were Malter's own foots prints. & the two shafts which he had shot, one feathered red, and one blue. he said at first: Belike someone bath been here. & hath had the carcase away. Then be laughed in very despite. & said: how may that be. since there are no 130

then is the carcase of the Lion?

abashed

Malter is signs of dragging away of so huge a body, and no blood or fur on the grass if they had cut him up. & moreover no trampling of feet, as if there had been many men at the deed. Then was heall abashed, and again laughed in scorn of himself. & said: forsooth I deemed I had done manly: but now forsooth I shot nought. & nought there was before the sword of my father's son. And what may I deem now, but that this is a land of merelies. & that there is nought real and alive therein save me. Vea. belike even these trees & the green grass will presently depart from me. & leave me falling down through the clouds. Therewith be turned away. & gat him to the road that led to the Golden House. wondering what next should befall him. and going slowly as he pondered his case. So came he to that first thicket where they had lost their quarry by water: so be entered the same, musing, and bathed him in the pool that was therein. after he had wandered about it a while, and found nothing new. #So again beset him to the homeward road,

when the day was now waning, and it Now was near sunset that he was comenigh comes the unto the house, though it was hidden Maid from him as then by a low bent that rose before him; & there he abode and looked about him.

bent came the figure of a wo-man, who stayed on the brow thereof and looked all about her, and then ran swiftly down to meet Malter. who saw at once that it was the Maid She made no stay then till she was but three paces from him, and then she stooped down and made the sign to him, & then spake to him breathlessly, and said: Bearken! but speak not till I havedone: I bade thee to night's meet, ing because I saw that there was one ar nigh whom I must needs bequile. But by thine oath, and thy love, and all that thou art. I adjure thee come not unto me this night as I bade thee! but be hidden in the hazel, copse outside the house, as it draws toward midnight. & abidemethere. Dost thou hearken, and wilt thou? Say yes or no in haste, for I

oftrvst

A change may not tarry a moment of time. Tho knoweth what is behind me PYes, said Malter hastily: but friend and love ... W No more, she said: hope the best: and turning from him she ran away swiftly, not by the way she had come. but sideways, as though to reach the house by fetching a compass.

> AT Malter went slowly on his way, thinking within himself bat now at that present moment there was nought for it but to rer frain him from doing, and to let others do: vet deemed he that it was little manly to be as the pawn upon the board, pushed about by the will of others 12 Then, as he went, he bethought him of the Maiden's face & aspect, as she came running to him, and stood before him for that minute; and all eagerness he saw in her. and sore love of him. & dis, tress of soul. all blent together.

Came he to the brow of the bent, whence he could see lying before him.scarcemore than a bow/shot

away. the Golden House. now gilded as gain and reddened by the setting sun.

And even therewith came a gay image The toward him.flashing back the level ravs from gold and steel and silver; and lo1 Son is there was come the King's Son. They met presently. & the King's Son turned to go beside him. & said merrily: I give thee good even, my Lady's Squire 1 I owe thee something of courtesy, where, as it is by thy means that I shall be made happy, both tomight, and tomorrow. and many to/morrows: and sooth it is. that but little courtes v have I done thee hitherto Bhis face was full of iov. and the eves of him shone with gladness. he was a goodly man, but to Walter he seemed an ill one: and he hated him so much. that he found it no easy matter to answer him: but he refrained himself. and said: I can thee thank. King's Son: and good it is that someone is happy in this strange land, Firt thou not happy then, Squire of my Lady? said the other B Malter had no mind to show this man his heart. nav. nor even a corner thereof: for he deemed him an enemy. So he smiled sweetly & somewhat foolishly, as a man luckily in love.

Kína's glad

he doubteth Malter

& said: O yea, yea, why should I not be so? how might I be otherwise? B Vea then, said the King's Son, why didst thou say that thou wert glad someone is happy? Tho is unhappy deemest thou? and he looked on him keenly B Malter answered slowly: Said I so? I suppose then that I was thinking of thee; for when first I saw thee. yea. and afterwards, thou didst seem heavyhearted and ill/content, # The face of the King's Son cleared at this word. & be said: Vea. so it was: for look you, both ways it was: I was unfree, and I had sown the true desire of my heart whereas it waxed not. But now I am on the brink and verge of freedom, & pres sently shall my desire be blossomed. Nay now, Squire, I deem thee a good fellow, though it may be somewhat of a fool; so I will no more speak riddles to thee. Thus it is: the Maid hath prov mised me all mine asking, and is mine; and in two or three days, by her helping also, I shall see the world again B Quoth Malter, smiling askance on him: And the Lady? what shall she say to

this matter? JE The King's Son red- The dened, but smiled falsely enough, and King's said: Sir Squire, thou knowest enough Son fears not to need to ask this. The should I nought in tell thee that she accounteth more of his joy thy little finger than of my whole body? Now I tell thee hereof freely: first. because this my fruition of love. and my freeing from thralldom, is, in a way, of thy doing. for thou art become my supr planter, and bast taken thy place with vonder lovely tyrant. fear not for mel she will let me go. As for thyself. see thou to it 1 But again I tell thee hereof because my heart is light and full of joy, and telling thee will pleasure me, & cannot do me any harm. for if thou say: how if I carry the tale to my Ladv? Ianswer, thou wilt not. for I know that thine heart hath been somewhat set on the iewel that my hand holdeth: & thou knowest wellon whose head the Lady's wrath would fall. & that would be neither thine nor mine B Thou sav, est sooth, said Malter: neither is treat son my wont.

1

Fie looks to come back happy to his own land O they walked on silently a while, and then Malter said: But how if the Maiden had nay, said thee; what hadst thou done then? By the heavens 1 said the King's Son fiercely, she should have paid for her nay say; then would I ... But he broke off. & said quietly.vet somewhat doggedly: Thy talk of what might have been? She gave me her yearsay pleasantly and sweetly BNow Malter knew that the man lied. so he held his peace thereon: but presently be said: Mhen thou art free wilt thou go to thine own land again? @Vea. said the King's Son: she will lead me thither. B Hnd wilt thou make her thy lady and queen when thou comest to thy father's land? said Malter, B The King's Son knit his brow, and said : Then I am in mine own land I may do with her what I will: but I look for it that I shall do no otherwise with her than that she shall be well/content.

DEN the talk between them drop, ped, and the King's Son turned off toward the wood, singing & joyous; but Malter went soberly to-

ward the house. forsooth he was not The lady greatly cast down, for besides that he asks all knew that the King's Son was false, he ter of his deemed that under this double tryst lay something which was a doing in his own behalf. Yet was he eager and troubled, if not down/hearted, and his soul was cast about betwixt hope and fear.

Chapter XX. Malter is bidden to another Tryst 광장

O came he into the pillar, ed hall, & there he found the Lady walking to and fro by the high, seat; & when he drew nigh she turned on him, & said in

a voice rather eager than angry: That hast thou done, Squire? Thy art thou come before me? I he was abashed, and bowed before her and said: O grav cious Lady, thou badest me service, & I have been about it I She said: Tell me then, tell me, what bath betided? I Lady, said he, when I entered the thicket of thy swooning I found there

The wrath of her

no carcase of the lion. nor any sign of the dragging away of him @Shelook, ed full in his face for a little, and then went to her chair. and sat down therein: and in a little while spake to him in a softer voice, and said: Did I not tell thee that some enemy had done that unto me? & loi now thou seest that so it is. B Then was she silent again. and knit her brows and set her teeth: and thereafter she spake harshly & fierce, ly:But I will overcome her. & make her days evil, but keep death away from her, that she may die many times over: and know all the sickness of the beart. when foes be nigh, and friends afar. & there is none to deliver 1 B her eves flashed, and her face was dark with any ger; but she turned and caught Malter's eyes, & the sternness of his face. and she softened at once. & said: But thou this hath little to do with thee: and now to thee I speak: Now cometh even and night. Go thou to thy chamber. and there shalt thou find raiment worthy of thee.what thou now art. and what thou shalt be: do on the same. & 148

make thyself most goodly, and then Malter come thou hither & eat and drink with new clad me. & afterwards depart whither thou wilt, till the night has worn to its midmost: & then come thou to my chamber. to wit. through the ivory door in the gallery above: and then and there shall I tell thee a thing, and it shall be for the weal both of thee & of me. but for the grief and woe of the Enemy. Therewithshereached her hand to him. and he kissed it, and departed & came to his chamber. & found raiment there, beforerich bevond measure: & he wons dered if any new snare lay therein: vet if there were, he saw no way whereby he might escape it. so he did it on. and ber came as the most glorious of kings, & vet lovelier than any king of the world. ITBENCE he went his way in, to the pillared hall, when it was nownight, & without the moon was up. & the trees of the wood as still as images. But within the hall shone bright with many candles. & the fountain alittered in the light of them. as it ran tinkling sweetly into the little

in the Golden house

Abanquet stream: & the silvern bridges gleamed, and the pillars shone all round about BAnd there on the dais was a table dight most rovally, and the Lady sitting thereat, clad in hermost glorious array, & behind her the Maid standing humbly, yet clad in precious web of shimmering gold, but with feet unshod, and the iron ring upon berankle. O Malter came his ways to the high/seat, and the Lady rose and greeted him, and took him by the hands, and kissed him on either cheek. & sat him down beside her. So they fell to their meat. & the Maid served them: but the Lady took no more heed of her than if she were one of the pillars of the hall: but Malter she caressed oft with sweet words, & the touch of her hand. making him drink out of her cup and eat out of her dish. Hs to him, he was bashfulby seeming, but verily fearful; he took the Lady's caresses with what grace hemight. Edurst not somuch as glance at her Maid. Long indeed seem ed that banquet to him, and longer vet endured the weariness of his abiding 150

there, kind to his foe and unkind to his Walter is friend; for after the banquet they still made sat a while, & the Lady talked much to much of Walter about many things of the ways of the world, and he answered what he might, distraught as he was with the thought of those two trysts which he

had to deal with. Clast spake the Lady and said: Nowmust I leave thee for a little, and thou wottest where and how weshallmeetnext; and meanwhiledis, port thee as thou wilt, so that thou weary not thyself, for I love to see thee iovous. Then she arose stately and grand: but she kissed Malter on the mouth ere she turned to go out of the hall. The Maid followed her: but or ever she was quite gone, she stooped and made that sign, and looked over her shoulder at Malter, as if in entreaty to him. & there was fear & anguish in her face: but he nodded his head to her in vea/sav of the tryst in the hazel/copse. and in a trice she was gone.

The Kína's Son is still jovous

BALTER went down the ball. and forth into the early night; but in the jaws of the porch he came up against the King's Son, who, gazing at his attire glittering with all its gems in the moonlight, laughed out, and said: Now may it be seen how thou art risen in degree above me, whereas I am but a king's son, and that a king of a far country; whereas thou art a king ofkings.orshalt be this night, yea, and of this very country wherein we both are. Now Malter saw the mock which lav under his words: but he kept back his wrath, and answered: fair sir, art thou as well contented with thy lot as when the sun went down? hast thou no doubt or fear? Mill the Maid verily keep tryst with thee, or hath she given thee yearsay but to escape thee this time?Or,again.may she not turn to the Lady & appeal to her against thee? Nowwhen he had spoken these words, he repented thereof. & feared for himself and the Maid. lest he had stirred some misgiving in that young man's foolish heart. But the King's Son did

but laugh. & answered nought but to They Malter's last words, & said: Yea, yea1 sunder this word of thine showeth how little thou wottest of that which lieth betwixt my darling and thine. Doth the lamb appeal from the shepherd to the wolf? Even so shall the Maid appeal from me to thy Lady. What 1 ask thy Lady at thy leisure what her wont bath been with her thrall: she shall think it a fair tale to tell thee thereof. But thereof is my Maid all whole now by reason of her wisdom in leechcraft. or somewhat more. And now I tell thee again. that the beforesaid Maid must needs do my will: for if I be the deep sea, & I deem not so ill of myself, that other one is the devil; as belike thou shalt find out for thyself later on. Yea, all is well with me, and more than well BAnd therewith he swung merrily into the litten hall.But Malter went out into the moonlitnight, and wandered about for an hour or more, and stole warily into the ball&thence into his own chamber. There he did off that roval array. & did hisown raiment upon him; he girt him

with sword & knife, took his bow and quiver, and stole down and out again, even as he had come in. Then he fetched a compass, and came down into that hazel coppice from the north, and lay all hidden there while the night wore, till he deemed it would lack but little of midnight.

Chapter XXI. Malterand the Maid flee from the Golden house 於於

BERE he abode amidst the hazels, harkening every littlest sound; & the sounds were nought but the night voices of the wood, till suddenly there

burst forth from the house a great wailing cry. Malter's heart came up in, to his mouth, but he had no time to do aught, for following hard on the cry came the sound of light feet close to him, the boughs were thrust aside, & there was come the Maid, and she but in her white coat, & barefoot. And then first he felt the sweetness of her flesh on his, for she caught him by the hand

& said breathlessly: Now, now! there On the may vet be time, or even too much, it way of may be. for the saving of breath ask me no questions, but comel # he dallied not. but went as she led. and they were light/foot, both of them.

DEY went the same way, due south to wit, whereby he had gone a/bunting with the Lady;

and whiles they ran & whiles they walk, ed: but so fast they went, that by grey of the dawn they were come as far as that coppice or thicket of the Lion: & still they hastened onward. & but little had the Maid spoken, save here & there a word to hearten up Malter, and here & there a shy word of endearment. Ht last the dawn grew into early day, & as they came over the brow of a bent, they looked down over a plain land whereas the trees arew scatter/meal. & beyond the plain rose up the land into long areen hills. and over those again were blue mountains great and far away. Then spake the Maid: Over yonder lie the outlying mountains of the Bears. & through them we needs must pass,

155

flight

They must needs rest

to our great peril 12 Nay, friend, she said, as he handled his sword/hilt. it must be patience and wisdom to bring us through, and not the fallow blade of one man, though he be a good one. But look | below there runs a stream through the first of the plain, and I see nought for it but we must now rest our bodies. Moreover I have a tale to tell thee which is burning my heart; for maybe there will be a pardon to ask of thee moreover ; wherefore I fear thee B Quoth Malter: Now may that be? She answered him not, but took his hand and led him down the bent. But he said: Thou sayest, rest; but are we nowout of all perilof the chase? @She said: I cannot tell till I know what hath befallen her. If she be not to hand to set on her trackers, they will scarce hap, pen on us now: if it benot for that one BAnd she shuddered, and he felt her hand change as he held it @ Then she said: But peril or no peril, needs must werest: for I tell thee again, what I have to say to thee burneth my bosom for fear of thee. so that I can go no further 156

until I have told thee B Then he said: H bath I wot not of this Queen & her mighti- withal ness & her servants. I will ask thereof later. But besides the others, is there not the King's Son, he who loves thee sounworthilv? @Shepaled somewhat. and said: As for him. there had been nought for thee to fear in him. save his treason: but now shall be neither love norbateanymore: bedied last midnight Dyea, & how? said Walter DNay, she said, let me tell my taleall together once for all. lest thou blame me overmuch. But first we will wash us and comfort us as best we may, and then amidst our resting shall the word be said.

then were they come down to 8 the stream/side, which ran fair in pools and stickles amidst rocks & sandy banks. She said: There behind the great grey rock is my bath. friend: and here is thine: and lo1 the uprising of the sun 1, #Soshe wenther ways to the said rock, & he bathed him. and washed the night off him, and by then he was clad again she came back freshand sweet from the water. & with

her lap full of cherries from a wilding which overhung her bath. So they sat down together on the green grass above the sand, & ate the breakfast of the wil/ derness: and Walter was full of content as he watched her, and beheld her sweetness and her loveliness; yet were they, either of them, somewhat shy & shamefaced each with the other; so that he did but kiss her hands once & again, and though she shrank not from him, yet had sheno boldness to cast herself into his arms.

Chapter XXII. Of the Dwarf and the Dardon 화 화

OM shebegan to say: My friend, now shall 1 tell thee what I have done for thee and me; and if thou have a mind to blameme, & punishme, yet remem/

berfirst, that what I have done has been for thee & our hope of happy life. All, I shall tell thee... But therewithal her speech failed her; and, springing up, she faced the bent and pointed with herfinger, & she all deadly pale, & shak/

ing so that she might scarce stand, & Two might speak no word, though a feeble shafts aibbering came from her mouth.

BALTER leapt up and put his arm about her, & looked whi-therward she pointed, and at first sawnought; and then nought but a brown and vellow rock rolling down the bent: & then at last he saw that it was the Evil Thing which had met him when first he came into that land; and now it stood upright, and he could see that it was clad in a coat of yellow sam, ite. B Then Malter stooped down and gat his bow into his hand, and stood before the Maid, while he nocked an ary row. But the monster made ready his tacklewhile Malter was stooping down. & or ever he could loose. his bow/string twanged, and an arrow flew forth and grazed the Maid's arm above the elbow. so that the blood ran. and the Dwarf gave forth a harsh & horrible crv. Then flew Malter's shaft. & true was it aimed. so that it smote the monster fullon the breast, but fell down from him as if he were made of stone. Then the creat

shot

Two wraths

ture set up his horrible cry again, and loosed withal. and Walter deemed that he had smitten the Maid, for she fell down in a heap behind him. Then waxed Walter wood/wroth, and cast down his bow and drew his sword, and strode forward towards the bent against the Dwarf. But he roared out again, and there were words in his roar. & he said: fool1 thoushalt go free if thou wilt give up the Enemy, BAnd who, said Malter, is the Enemy? JE Velled the Dwarf: She. the pink & white thing lying there; she is not dead vet: she is but dving for fear of me. Vea. she hath reason 1 I could have set the shaft in her heartas easily as scratching herarm; but I need her body alive, that I may wreak me on her. Matwilt thou do with her? said Walter: for now he had heard that the Maid was not slain he had waxed wary again. & stood watching his chance The Dwarf yelled so at his last word. that no word came from the noise a while. & then he said: What will I with her? Let meat her, and stand by & look on, and then shalt thou have a strange 160

tale to carry off with thee. for I will let The thee go this while @ Said Malter: But cleaving whatneed to wreak thee? What hath she of a head donetothee? # Whatneed (whatneed) roared the Dwarf: have I not told thee that sheis the Enemy? And thou askest of what she hath done of what 1 fool. she is the murderer! she hath slain the Lady that was our Lady, and that made us: she whom all we worshipped and adored. O impudent fool Etherewith he nocked & loosed anotherarrow, which would have smitten Malter in the face, but that he lowered his head in the very nick of time: then with a great shout he rushed up the bent, and was on the Dwarf before he could get his sword out, and leaping aloft dealt the creature a stroke amidmost of the crown: and so mightily he smote. that he drave the heavy sword right through to the teeth, so that he fell dead straightway.

HLTER stood over him amin nute, and when he saw that he moved not, he went slowly down to the stream, whereby the Maid m 161

ís sore afeard

The Maid vetlav cowering down and guivering all over. & covering her face with her hands. Then he took her by the wrist & said: Ap Maiden. up1 and tell me this tale of the slaving ! @ But she shrunk away from bim. and looked at bim with wild eves. and said: What hast thou done with him? Is he gone? JE he is dead, said Walter: I have slain him: there lies he with cloven skull on the bent/side: unless. forsooth. he vanish away like thelion Islew | or else, perchance, he will come to life again 1 And art thou a lie like to the rest of them? let me hear of this slaving.

herose up, & stood before him trembling, and said: O, thou art angry with me, and thine anger I cannot bear. Hb. what have I done? Thou hast slain one. and I. mavbe. the other: & never had we escaped till both these twain were dead. Hhi thou dost not know 1 thou dost not know 10 me1 what shall I do to appease thy wrath! Clooked on her, & his heart rose sundering from her. Still he look to his mouth at the thought of

edon her, and her piteous friendly face friends at melted all his heart; he threw down his one again sword, and took her by the shoulders. and kissed her face over and over, and strained ber to him. so that he felt the sweetness of her bosom. Then belifted her up like a child. and set her down on the green grass, and went down to the water. and filled his hat therefrom. and came back to her: then he gave her to drink, and bathed her face and her hands, so that the colour came aback to the cheeks and lips of her: and she smiled on him. & kissed his hands, and said: O now thou art kind to me. Wea. said he, and true it is that if thou hast slain. I have done no less, and if thou hast lied. even so have I: & if thou hast played the wanton, as I deem not that thou hast, I full surely have so done. So now thou shalt pardon me, & when thy spirit has come back to thee, thou shalt tell me thy tale in all friendship, and in all loving/kindness will I bearken the same.

m 2

She thinketh of the burial

BEREMITS he knelt before her & kissed her feet. But she said: Yea, yea; what thou willest, that will I do. But first tell me one thing. Bast thou buried this horror & hidden him in the earth? Bhe deemed that fear had bewildered her, and that she scarcely vet knew how things had gone. But he said: fair sweet friend, I have not done it as yet; but now will I go and do it, if it seem good to thee, Yea.shesaid.butfirstmustthousmite off his head, and lay it by his buttocks when he is in the earth: or evil things will happen else. This of the burying is no idle matter, I bid thee believe BI doubt it not. said he: surely such malice as was in this one will be hard to slay. And he picked up his sword, and turned to go to the field of deed, BShe said: I must needs go with thee: terror hath so filled my soul, that I durst not abide here without thee.

where the creature lay. The Maid where the creature lay. The Maid durst not look on the dead monster, but Walter noted that he was girt

with a big ungainly sax; so he drew it They from the sheath, and there smote off leave the the bideous head of the fiend with his place own weapon. Then they twain together laboured the earth, she with Malter's sword, he with the ugly sax, till they had made a grave deep & wide enough; and therein they thrust the creature, and covered him up, weapons and all together.

Chapter XXIII. Of the peaceful ending of that wild day 323

bereffter Maid down again, & said to her: Now, sweet/ ling, shall the story be told W Nay friend, she said, not here. This place bath

been polluted by my craven fear, and the borror of the vile wretch, of whom no words may tell his vileness. Let us bence and onward. Thou seest I have oncemore come to life again But, said he, thou hast been burt by the Dwarf's arrow She laughed, and said: Fad I never had greater burt from them than The Maid that, little had been the tale thereof: is eager to yet whereas thou lookest dolorous ago bout it, we will speedily heal it There

with she sought about, & found nigh the stream/side certain herbs: and she spakewords over them, and bade Malter lay them on the wound, which, forsooth, was of the least, and he did so, and boundastrip of his shirt about her arm: and then would she set forth. But he said: Thou art all unshod: and but if that be seen to, our journey shall be stayed by thy foot/soreness: I may make a shift to fashion thee broques She said: I may well go barefoot. And in any case. I entreat thee that we tarry herenolonger, but go away hence, if it bebut for a mile BAnd she looked piteously on him, so that he might not gainsav her.

O then they crossed the stream, and set forward, when amidst all these haps the day was worn to mid/morning. Butafter they had gone a mile, they sat them down on a knoll under the shadow of a big thorn/tree, within sight of the mountains. Then 166

said Malter: Now will I cut thee the Of the broques from the skirt of my buff, coat, dwarfwhich shall be well meet for such work: kin and meanwhile shalt thou tell me thy tale B Thou art kind. she said : but be kinder vet. & abide my tale till we have done our day's work. For we were best to make no long delay here: because. though thou hast slain the King dwarf. vet there be others of his kindred. who swarm in some parts of the wood as the rabbits in a warren. Now true it is that they have but little understanding, less, it may be, than the very brute beasts; and that, as I said afore, unless they be set on our slot like to bounds. they shall have no inkling of where to seek us. vet might they happen upon us by mere misadventure. And moreoverfriend.quothshe.blushing.Iwould beg of thee some little respite: for thoughIscarce fear thy wrath any more, since thou hast been sokind tome. vet is there shame in that which I have to tell thee. Therefore since the fairest of the day is before us. let us use it all we may, and, when thou hast done me my 167

Malter maketh the Maid shoes

new footigear, get us gone forward agaín.

E kissed ber kindly and yearsaid ber asking: De Dau and in a to work on the leather, and in a while had fashioned her the broques; so she tied them to her feet, and arose with a smile & said: Now am I hale and strong again, what with the rest, and what with thy loving/kindness. & thou shalt see hownimble I shall be to leave this land, for as fair as it is. Since forsooth a land of lies it is, and of grief to the children of Hdam.

O they went their ways thence, & fared nimbly indeed, & made no stay till some three hours af ter noon, when they rested by a thicket, side, where the strawberries grew plenty: they ate thereof what they would: & from a great oak hard by Malter shot him first one culver, and then another, & hung them to his girdle to be for their evening's meat: sithence they went for, ward again, and nought befell them to tell of, till they were come, whenas it lacked scarce an hour of sunset. to the 168

banks of another river, not right great. Now they but bigger than the last one. There the rest for Maid cast herself down & said: friend. the even no further will thy friend go this even: nav. to sav sooth, she cannot. So now we will eat of thy venison. & then shall my tale be, since I may no longer delay it: and thereafter shall our slumber be sweet and safe as I deem B She spake merrilv now. and as one who feared no, thing, and Malter was much heartened by her words and her voice. and he fell to and madea fire. and a woodland oven in the earth, and sithence dighted his fowl.& baked them after the manner of woodmen. And they ate, both of them. in all love, & in good/liking of life. and were much strengthened by their supper. And when they were done. Malter eked his fire, both against the chill of the midnight and dawning, and for a guard against wild beasts, and by that time night was come, and the moon arisen. Then the Maiden drew up to the fire. and turned to Walter and spake.

Chapter XXIV. The Maid tells of what had befallen her 惑 惑

OM, friend, by the clear of the moon & this firelight will I tell what I may and can of my tale. Thus it is: If I be wholly of the race of H dam I wot not:

nor can I tell thee how many years old I may be. for there are, as it were, shards or gaps in my life, wherein are but a few things dimly remembered, and doubts less many things forgotten. I remem, ber well when I was a little child, and right happy, & there were people about mewhom I loved, and who loved me. It wasnotin this land; but all things were lovely there; the year's beginning, the happy mid/year, the year's waning, the year's ending, & then again its begin ning. That passed away, and then for a while is more than dimness, for nought Iremember save that I was. Thereafter I remember again, & am a young maid, en, and I know some things, and long toknow more. I am nowise happy; I am

amongst people who bid me go, and I H teacher go: and do this. & I do it: none loveth me.nonetormenteth me: butIwearmy heart in longing for Iscarce know what. Neither then am I in this land, but in a land that I love not. and a house that is big & stately, but nought lovely. Then is a dim time again. and sithence a time not right clear: an evil time. wherein I am older, wellinigh grown to womanbood. There are a many folk about me. and they foul, and greedy, and hard: & my spírit is fierce, but my body feeble: and I am set to tasks that I would not do. by them that are unwiser than I: & smitten I am by them that are less valiant than I: and I knowlack. & stripes. and divers miserv. But all that is now become but a dim picture to me. save that amongst all these unfriends is a friend to me: an old woman, who telleth me sweet tales of other life.wherein all is high & goodly, or at the least var liant and doughty, & she setteth hope in my beart and learneth me, & maketh me to know much ... O much ... so that at last I am grown wise, and wise to be

She is marked for a thrall mighty if I durst. Yet am I nought in this land all this while, but, as meseem/ eth, in a great and a foul city.

ND then, as it were, I fall asleep; and in my sleep is nought, save here & there a wild dream, some deal lovely, somedeal hideous: but of this dream is my Mistress a part, and the monster, withal, whose head thou dídst cleave torday. But when I am awaken from it, then am I verily in this land, and myself, as thou seest me tor day. And the first part of my life here is this, that I am in the pillared hall vonder.half/clad & with bound hands: and the Dwarf leadeth me to the Lady. and I hear his horrible croak as he sav eth: Lady, will this one do? & then the sweet voice of the Lady saving : This one will do: thou shalt have thy reward: now, set thou the token upon her. Then I remember the Dwarf dragging me ar way, and my heart sinking for fear of him: but for that time be did me no more harm than therivetting upon my leg this iron ring which here thou seest.

of the Lady; & I remember my life notes the here day by day, & no part of it has fal, Maid's len into the dimness of dreams. There, wisdom of will I tell thee but little: but this I will tell thee, that in spite of my past dreams.or it may be because of them.I had not lost the wisdom which the old woman had erst learned me. & for more wisdom I longed. Maybe this longing shall now make both thee & me happy, but for the passing time it brought me grief. for at first my Mistress was indeed wayward with me. but as any great lady might be with her bought thrall. whiles caressing me, and whiles chastising me, as her mood went: but she seemed not to be cruel of malice. or with any set purpose. But so it was (rather little by little than by any great sudden uncovering of my intent). that she came to know that I also had some of the wis, dom whereby she lived her queenly life. That was about two years after I was first her thrall, and three weary years have gone by since she began to see in

The Dwarf is threatened

me the enemy of her days. Now why or wherefore I know not. but it seemeth that it would not avail her to slav me out, right, or suffer me to die: but nought withheld her from piling up griefs and miseries on my head. Ht last she set her servant, the Dwarf, upon me, even he whose head thou clavest to/day. Many things I bore from him whereof it were unseemly for my tongue to tell before thee: but the time came when he exceed, ed. and I could bear no more: and then I showed him this sharp knife (where, with I would have thrust me through to the heart if thou hadst not pardoned me e'en now). & I told him that if he for, bore me not, I would slav, not him, but myself; and this he might not away with because of the commandment of the Lady, who had given him the word that in any case I must be kept living. And her hand, withal, fear held somewhat hereafter. Vet was there need to me of all my wisdom; for with all this her hatred grew, & whiles raged within her so furiously that it overmaster, ed her fear. & at such times she would

have put me to death if I had not es- Of the caped her by some turn of my lore. OW further, I shall tell thee that theKing's somewhat more than a year a- Son go hither to this land came the King's Son, the second goodly man. as thou art the third, whom her sorceries have drawn bither since I have dwelt here. forsooth. when he first came. he seemed to us, to me, & vet more to my Lady, to be as beautiful as an angel. and sorely she loved him ; & he her, af, ter his fashion: but he was light/mind/ ed, and cold, bearted, and in a while be mustneeds turn his eves upon me.and offer me his love, which was but foul and unkind as it turned out: for when I nay said him, as maybe I had not done save for fear of my Mistress, he had no pity upon me, but spared not to lead me into the trap of her wrath, and leave me without help, or a good word. But, O friend, in spite of all grief and anquish. I learned still. and waxed wise. and wiser, abiding the day of my deliverance, which has come, and thou art come.

comingof

Of the vision at Langton

herealth she took Malter's hands and kissed them; but he kissed her face, & her tears wet his lips. Then she went on: But sithence. months ago, the Lady began to weary of this dastard, despite of his beauty: & then it was thy turn to be swept into her net: I partly guess how. for on a day in broad daylight, as I was serving my Mistress in the hall, and the Evil Thing. whose head is now cloven. was lving across the threshold of the door. as it were a dream fell upon me, though I strove to cast it off for fear of chastisement; for the pillared hall wavered, and vanished from my sight, and my feet were treading a rough stone paver ment instead of the marble wonder of the ball, and there was the scent of the salt sea and of the tackle of ships. and behind me were tall houses, and before me the ships indeed, with their ropes beating and their sails flapping & their masts wavering; and in mine ears was the hale and how of mariners: things that I had seen and heard in the dimness of my life gone by B And there 176

was I. & the Dwarf before me. and the The Ladvafterme.going overthe gangway blazon of aboard of a tall ship, and she gathered the ancient way and was gotten out of the haven. & straightway I saw the mariners cast abroad their ancient, BQuoth Malter: What then 1 Sawest thou the blazon thereon, of a wolf/like beast ramping up against a maiden? And that might well have been thou @ She said : Yea. so it was: but refrain thee. that I may tell on my tale | The ship and the sea vanished away, but I was not back in the hall of the Golden House: & again were we three in the street of the selfsame town which we had but just left: but somewhat dim was my vision there, of, and I saw little save the door of a goodly house before me, and speedily it died out, and we were again in the pile lared hall. wherein my thralldom was made manifest.

HIDEN, said Malter, one quest tion I would ask thee; to wit, dídst thou see me on the quay by the ships? J Nay, she said, there were many folk about, but they were

n

in a new cítv

They are all as images of the aliens to me. Now bearken further: three months thereafter came the dream upon me again, when we were all three together in the Dillared Hall: & again was the vision somewhat dim. Once more we were in the street of a busy town, but all unlike to that other one, and there were men standing together on our right hands by the door of a house I Yea, yea. quoth Malter: and, forsooth, one of them was who but I BRefrain thee.be, loved1 she said; for my tale draweth to its ending. & I would have thee hearken heedfully: for maybe thou shalt once again deem my deed past pardon. Some twenty days after this last dream. I had some leisure from my Mistress's service, solwent to disport me by the Mell of the Oakstree (or forsooth shemight have set in my mind the thought of go, ing there, that I might meet thee and give her some occasion against me): & I sat thereby, nowise loving the earth. but sick at heart, because of late the King's Son had been more than ever in, stant with me to yield him my body. 178

threatening me else with casting me foreinto all that the worst could do to me of torments and shames day by day. I sav my heart failed me. & I was wellnigh brought to the point of yea/saying his desires, that I might take the chance of something befalling me that were less bad than the worst. But here must I tell thee a thing, and pray thee to take it to heart. This, more than aught else, had given me strength to nay, say that dastard, that my wisdom both hath been, & now is, the wisdom of a wise maid. & not of a woman. and all the might thereof shall I lose with my maidenhead. Evil wilt thou think of me then, for all I was tried so sore. that I was at point to cast it all away. so wretchedly as I shrank from the borror of the Lady's wrath.

Magat thereas Isat pondering these things, I saw a man coming, and athoughtnootherwisethereofbut that it was the King's Son, till I saw the stranger drawing near. Chisgolden hair, and his grey eyes; & then I heard his voice, and his kindness pierced my 170

n 2

bodings ofevil

feareth agaín

The Maid heart, and I knew that my friend had come to see me: and O, friend, these tears are for the sweetness of that past hourf

HID Malter: I came to see my friend, Lalso. Nowhave I noted what thou badestme; and I will forbear allas thou commandest me, till we be safe out of the desert & far away from all evil things: but wilt thou ban me from all caresses? BShe laughed ar midst of her tears. & said: O. nav. poor lad, if thou wilt be but wise B Then she leaned toward him, & took his face betwixt her hands and kissed him oft. & the tears started in his eves for love and pity of her B Then she said : Hlas, friend l even vet mayst thou doom me guilty, and all thy love may turn away from me, when I have told thee all that I have done for the sake of thee & me. O, if then there might be some chastisement for the guilty woman, and not mere sundering 1, # fear nothing. sweetling, said he: for indeed I deem that already I know partly what thou hast done.

DE sighed, and said: I will tell how the thee next, that I banned thy kiss, Maidtook

ing & caressing of me till to, day rede from becauseIknewthatmy Mistress would surely know if a man, if thou, hadst so muchas touched a finger of mine in love. It was to try me berein that on the morn, ing of the hunting she kissed and embraced me, till I almost died thereof.& showed theemy shoulder & my limbs: & to try thee withal. if thine eveshould glister or thy cheek flush thereat: for indeed she was raging in jealousy of thee. Next, my friend, even whiles we were talking together at the Mell of the Rock, I was pondering on what we should do to escape from this land of lies. Maybe thou wilt say: Why didst thou not takemy hand and flee with me as wefled to/day?friend,it is most true, that were she not dead we had not escaped thus far. for her trackers would have followed us, set on by her, and brought us back to an evil fate. Therefore I tell thee that from the first I did plot the death of those two, the Dwarf &theMistress.fornootherwisemiaht, 181

the first

Concerning that tryst

est thou live, or I escape from death in life. But as to the dastard who threatened me with a thrall's pains. I heeded him nought to live or die. for well I knew that thy valiant sword, yea, or thy bare hands, would speedily tame him. Now first I knew that I must make a show of vielding to the Kings' Son: & somer what how I did therein, thou knowest. But nonight & no time did I give him to bed me. tillafter I had met theeas thou wentest to the Golden House, before the adventure of fetching the lion's skin: and up to that time I had scarce known what to do. save ever to bid thee, with sore grief and pain, to yield thee to the wicked woman's desire. But as we spake together there by the stream. and I saw that the Evil Thing (whose head thou clavest e'en now) was spying on us. then amidst the sickness of terror which ever came over me whensoever I thought of him. and much more when I saw him (ab1 he is dead now1). it came flashing into my mind how I might destroy my enemy. Therefore I made the Dwarf my messenger to her. 182

by bidding thee to my bed in such wise Concernthat he might hear it. And wot thou ing that well, that he speedily carried her the lion tidings. Meanwhile I hastened to lie to the King's Son. and all privily bade him come to me & not thee. And thereafter. by dint of waiting and watching, and taking the only chance that there was. I met thee as thou camest back from fetching the skin of the lion that never was, and gave thee that warning, or else had we been undone indeed B Said Malter: Mas the lion of her making or of thine then? @ She said: Of hers: why should I deal with such a matter? Jea, said Malter, but she verily swooned. & she was verily wroth with the Enemy F The Maid smiled, and said: If her lie was not like very sooth, then had she not been the crafts/mas/ ter that I knew her: one may lie otherwise than with the tongue alone: yet indeed her wrath against the Enemy was nought feigned; for the Enemy was even I, & inthese latter days never did her wrath leave me. But to go on with my tale. W Now doubt thou not. 183

fell while Malterlav in the hazelcopse

That be- that, when thou camest into the hall vester eve, the Mistress knew of thy counterfeit tryst with me. and meant nought but death for thee: vet first would she have thee in her arms again. therefore did she make much of thee at table (and that was partly for my torment also), and therefore did she make that tryst with thee. and deemed doubtless that thou wouldst not dare to forgo it. even if thou shouldst go to me thereafter, BNow I had trained that dastard to me as I have told thee. but I gave him a sleepy draught, so that when I came to the bed he might not move toward menoropen his eyes: but I lav down beside him. so that the Lady might know that my body had been there: for well had she wotted if it had not. Then as there I lay I cast over him thy shape, so that none might have known, but that thou wert lying by my side, & there, trembling, I abode what should befall. Thus I passed through the hour whenas thou shouldest have been at her chamber. and the time of my tryst with thee was come as the Mis-184

tress would be deeming: so that I look, ed for her speedily, and my heart well, nich failed me for fear of her cruelty @ Dresently then I heard a stirring in her chamber. and I slipped from out the bed. and hid me behind the hangings. and was like to die for fear of her; & lo. presently she came stealing in softly. holding a lamp in one hand and a knife in the other. And I tell thee of a sooth that Ialso had a sharp knife in my hand to defend my life if need were. She held the lamp up above her head before she drew near to the bed/side, and I heard her mutter: She is not there then 1 but she shall be taken. Then she went up to the bed and stooped over it. & laid ber hand on the place where I had lain: and therewith her eves turned to that false image of thee lying there, & she fell astrembling and shaking, and the lamp fell to the ground & was quenched (but there was bright moonlight in the room. and still I could see what ber tid). But she uttered a noise like the low roar of a wild beast. and I saw her arm and hand rise up, and the flashing 185

further

while

tidings in that same Vet of the steel beneath the hand, and then further down came the hand and the steel. and I wentnigh to swooning lest perchance I had wrought over well, & thine image were thy very self. The dastard died without a groan: why should I lament him? I cannot. But the Lady drew him toward her, and snatched the clothes from off his shoulders and breast, and fell agibbering sounds mostly without meaning, but broken here & there with words. Then I heard her say: I shall forget; I shall forget: & the new days shall come. Then was there silence of her a little, and thereafter she cried out in a terrible voice: O no. no. no! I cannot forget: I cannot forget: & she raised a great wailing cry that filled all the night with horror (didst thou not hear it?), and caught up the knife from the bed and thrust it into her breast, and fell down a dead heap over the bed and on to the man whom she had slain. And then I thought of thee, and joy smote across my terror; how shall I gainsavit? And I fled away to thee, and I took thine hands in mine, thy dear 186

hands, & we fled away together. Shall Malter we be still together?

E spoke slowly, & touched her the Maid's En not, and she, forbearing all sobbing and weeping, sat looking wistfully on him. Besaid: I think thou bast told me all: and whether thy quile slew her. or her own evil heart. she was slain last night who lay in mine arms the night before. It was ill. and ill done of me. for I loved not her, but thee, and I wished for her death that I might be with thee. Thou wottest this, and still thou lovestme, it may be overweeningly. What have I to say then? If there be any quilt of quile. Ialso was in the quile: and if there be any guilt of murder, I also was in the murder. Thus we sav to each other: and to God & his Ballows we sav: Me two have conspired & slain the woman who tormented one of us.& would have slain the other: and if we have done amiss therein, then shall we two together pay the penalty; for in this have we done as one body and one soul.

answereth tale

heremith he put his arms about her and kissed her, but soberly and friendly, as if he would comfort her. And thereafter he said to her: Maybe to/morrow, in the sunlight. I willask thee of this woman. what she verily was: but now let her be. And thou, thou art over/wearied, and I bid thee sleep So he went about and gathered of bracken a great heap for her bed. and did his coat thereover, and led her thereto. & she lav down meekly, and smiled and crossed her arms over her bosom, and presently fell asleep. But as for him. he watched by the fireside till dawn began to glimmer, & then he also laid him down and slept. Chapter XXV. Of the triumphant

Chapter XXV. Of the triumphant Summer Hrray of the Maid 或 或

DEN the day was bright Walter arose, & met the Maid coming up from the river/bank, fresh & rosy from the water.She paled a little when they met face to face, & she shrank from him shyly. But he took her hand and kissed her Concernfrankly: and the two were glad. & had ing the no need to tell each other of their joy, Bearsfolk though much else they deemed they had to say could they have found words thereto.

O they came to their fire and sat down, and fell to breakfast; & ere they were done, the Maid said:

My Master, thou seest we be comeniah unto the hill country, and to day about sunset, belike, we shall come into the Land of the Bear, folk: & both it is. that there is peril if we fall into their hands. and that we may scarce escape them. Vet I deem that we may deal with the peril by wisdom, Walhat is the peril? said Malter; I mean, what is the worst of it? @ Said the Maid: To be offered up in sacrifice to their God But if we escape death at their hands, what then? said Malter BOne of two things, said she: the first, that they shall take us into their tribe # And will they sunder us in that case? said Malter @ Nav, said she Walter laughed and said: There, in is little harm then. But what is the 180

Of the Godof the Bears

otherchance? @Said she: That we leave them with their good will. & come back to one of the lands of Christendom Said Malter: I am not all so sure that this is the better of the two choices. though, forsooth, thou seemest to think so. But tell me now. what like is their God, that they should offer up new/comers to him? @ Their God is a woman, she said, and the Mother of their nation & tribes (or so they deem) before the days when they had chieftains and Lords of Battle F Chat will be long ago, said he: how then may she beliving now? @Said the Maid: Doubt, less that woman of yore agone is dead this many & many a year; but they take to them still a new woman, one after other, as they may happen on them, to be in the stead of the Ancient Mother. And to tell thee the very truth right out, she that lieth dead in the Dillared Ball was even the last of these: and now, if they knew it, they lack a God. This shall we tell them J Yea, yea! said Malter, a goodly welcome shall we have of them then, if we come amongst

them with our hands red with the blood Tho shall of their God! @ She smiled on him & be their said: If I come amongst them with the Godnow? tidings that I have slain her. and they trow therein. without doubt they shall make me Lady & Goddess in her stead B This is a strange word. said Malter: but if so they do, how shall that further us in reaching the kindreds of the world, and the folk of holv Church?

DE laughed outright, so joyous was she grown, now that she knew that his life was yet to be a part of hers. Sweetheart, she said.

now I see that thou desirest wholly what I desire: vet in any case, abiding with them would beliving & not dving. even as thou hadst it e'en now. But. forsooth. they will not hinder our departure if they deem me their God: they do not look for it, nor desire it, that theirGod should dwell with them daily. Bave no fear. Then she laughed again. & said: What 1 thou lookest on me and deemest me to be but a sorry image of a goddess: & me with my scanty coat and bare arms & naked feet | But wait |

H fair place I know well how to array me when the time cometh. Thou shalt see it! And now, my Master, were it not meet that we took to the road?

O they arose, and found a ford of The river that took the Maid but to the knee, and so set forth up the greensward of the slopes whereas there were but few trees: so went they faring toward the hill country B Ht the last they were come to the feet of the very hills, and in the hollows betwixt the buttresses of them arew nut and berry trees, and the greensward round about them was both thick and much flowery. There they stayed them and dined, whereas Malter had shot a hare by the way, and they had found a bubbling spring under a grey stone in abight of the coppice, wherein now the birds were singing their best.

DEN they had eaten and had rested somewhat, the Maid aroseand said: Now shall the Queen array herself, & seem like a very goddess, & Chen she fell to work, while Walter looked on; and she made a gar-

land for her head of eqlantine where The the roses were the fairest: & with min- Mother of gledflowers of the summer she wreath, Summer ed her middle about. and let the garland of them hangdown to below her knees: and knots of the flowers she made fast to the skirts of her coat. and did them for arm/rings about her arms, and for anklets and sandals for her feet. Then sheset a garland about Walter's head. and then stood a little off from him and set her feet together, and lifted up her arms, and said: Lo now! am I not as like to the Mother of Summer as if Iwere clad in silk and gold? and even so shall I be deemed by the folk of the Bear. Come now. thou shalt see how all shall be well.

The laughed joyously; but he might scarce laugh for pity of his love. Then they set forth again, and began toclimb the hills, and the hours wore as they went in sweet converse; till at last Walter looked on the Maid, and smiled on her, and said: One thing I would say to thee, lovely friend, to wit: wert thou clad in silk &

0

The flowers fade? or comealive again?

gold, thy stately raiment might well suffer a few stains, or here and there a rentmavbe: but stately would it be still when the folk of the Bear should come up against thee. But as to this flowerv array of thine. in a few hours it shall be all faded & nought. Nav. even now. as I look on thee. the meadow, sweet that hangeth from thy girdle, stead has waxen dull. & welted: and the blos, soming evebright that is for a hem to the little white coat of thee is already forgetting how to be bright and blue. Whatsavestthouthen? @Shelaughed at his word, and stood still, and looked back over her shoulder. while with her fingers she dealt with the flowers about herside like to a bird preening his feathers. Then she said: Is it verily so as thou savest? Look again 1 # So he looked.&wondered:forloibeneathhis eves the spires of the meadow/sweet grew crisp & clear again, the eyebright blossoms shone once more over the whiteness of her leas: the ealantine roses opened, and all was as fresh and bright as if it were still growing on 194

its own roots.

E wondered, & was even some- downs deal aghast; but she said: Dear friend. benot troubled 1 did Inot tell thee that I am wise in hidden lore? But in my wisdom shall be no longer any scathe to any man. And again, this my wisdom, as I told thee erst, shall end on the day whereon I am made all happy. And it is thou that shall wield itall.my Master. Vet must my wisdom needs endure for a little season yet. Let us on then, boldly and happily.

Chapter XXVI. They come to the folk the Bears A A

N they went, and before long they were come up on to the down/country, where was scarce a tree, save gnarled and knotty thorn bushes here and

there, but nought else higher than the whin. And here on these upper lands they saw that the pastures were much burnt with the drought, albeit summer was not worn old. Now they went mak-

On the

H dale of the downs ing due south toward the mountains. whose heads they saw from time to time rising deep blue over the bleak grevness of the downland ridges. And so they went. till at last. hard on sunset. after they had climbed long overabigh bent, they came to the brow thereof. &. looking down, beheld new tidings. There was a wide valley below them, areener than the downs which they had come over, and greener vet amidmost. from the watering of a stream which. all beset with willows, wound about the bottom. Sheep & neat were pasturing about the dale, & moreover a long line of smoke was going up straight into the windless heavens from the midst of a ring of little round houses built of turfs, and thatched with reed. And bevond that, toward an eastward/lying bight of the dale, they could see what lookedliketoadoomringofbigstones. though there were no rocky places in that land. About the cooking fire amidst of the houses, and here & there otherwhere, they saw, standing or going to and fro, huge figures of men and 106

women, with children playing about ber The twirt them.

BEY stood and gazed down at it dwellers for a minute or two, & though all were at peace there, yet to Malter,

at least, it seemed strange & awful. De spake softly, as though he would not have his voice reach those men. though they were.forsooth.out of ear/shot of anything save a shout: Hre these then the children of the Bear? What shall we do now? . # She said: Yea, of the Bear they be, though there be other folks of them far & far away to the northward & eastward, near to the borders of the sea. And as to what we shall do. let us go down at once, and peacefully. Indeed, by now there will be no escape from them: for lo vou 1 they have seen us.

ORSOOTH, some three or four of the big men had turned them toward the bent whereon stood the twain, & were bailing them in buge. rough voices.wherein.howsoever.seem ed to beno anger or threat. So the Maid took Malter by the hand, and thus they 107

down-

The like went down quietly, and the Bear, folk, of them seeing them, stood all together, facing them.toabide their coming. Malter saw of them, that though they were very tall and bigly made, they were not so far as bove the stature of men as to be marvels. The carles were long/haired. and shaggy of beard, and their hair all red or tawny: their skins.where their naked flesh showed, were burned brown with sun & weather, but to a fair and pleasant brown.nought like to blackamoors. The queans were comely & well/eved: nor was there anything of fierce or evil looking about either the carles or the queans, but somewhat grave and solemn of aspect were they. Clad were they all, saving the young men/children, but somewhat scantily, and in nought save sheep/skins or deer/skins. @for weapons they saw amongst them clubs, & spears headed with bone or flint, and ugly axes of big flints set in wooden handles: nor was there, as far as they could see, either now or afterward, any bow amongst them. But some of the voungmen seemed to have slings done 108

about their shoulders.

Old when they were come but mere three fathom from them, the alient Maid lifted up her voice, and spake clearly and sweetly: hail, ye folk of the Bears 1 we have come amongst you, & that for your good and not for your hurt: wherefore we would know if we be welcome.

BERE was an old man who stood foremost in the midst. clad in a mantle of deer/skins worked very goodly, and with a gold ring on his arm, and a chaplet of blue stones on his head, and he spake: Lit, tle are ve, but so goodly, that if ve were but bigger. we should deem that ve were come from the Gods' house. Vet have I heard.that how mighty soever may the Gods be. & chiefly our God. they be at whiles nought so bigly made as we of the Bears. how this may be, I wot not. But if ve be not of the Gods or their kindred, then are ve mere aliens: & we know not what to do with aliens, save we meet them in battle, or give them to the God.orsavewemake them children

Gods or mere aliens?

will answer at the Mote

The Maid of the Bear. But yet again, ye may be messengers of some folk who would bind friendship and alliance with us: in which case ve shall at the least depart in peace, and whiles ye are with us shall be our guests in all good cheer. Now, therefore, we bid you declare the matter unto us B Then spake the Maid: father. it were easy for us to declare what we be unto you here present. But, meseemeth, ye who be gathered round the fire here this evening are less than the whole tale of the children of the Bear, So it is, Maiden, said the elder, that many more children hath the Bear. @ This then we bid you, said the Maid, that ve send the tokens round & gather your people to you, and when they be assembled in the Doom/ring. then shall we put our errand before vou: and according to that, shall ve deal with us, F Thou hast spoken well, said the elder; and even so had we bidden vou ourselves. Tosmorrow, before noon. shall ve stand in the Doom/ring in this Dale, & speak with the children of the Bear.

heremith he turned to his Supper own folk & called out something, amidst of whereof those twain knewnot the the Bears

meaning: & there came to him, one after another, six young men. unto each of whom he gave a thing from out his pouch, but what it was Malter might not see. save that it was little and of small account: to each, also, he spake a word or two. & straight they set off running. one after the other, turning toward the bent which was over against that whereby the twain had come into the Dale, and were soon out of sight in the gathering dusk.

DEN the elder turned him again to Malter and the Maid, & spake: Man and woman, whatsoever ye

may be, or whatsoever may abide you to, morrow, to, night, ye are welcome quests to us: so we bid you come eat and drink at our fire.

O they sat all together upon the grass round about the embers of the fire, and ate curds and cheese,

and drank milk in abundance; & as the night arewon them they quickened the

The Bears are shy of the aliens fire, that they might have light. This wild folk talked merrily amongst them, selves, with laughter enough & friend, ly jests, but to the new, comers they were few, spoken, though, as the twain deemed, for no enmity that they bore them. But this found Walter, that the younger ones, both men and women, seemed to find it a hard matter to keep their eyes off them; and seemed, withal, to gaze on them with somewhat of doubt, or, it might be, of fear.

O when the night was wearing a little, the elder arose and bade the twain to come with him, and led them to a small house or booth, which was amidmost of all, and somer what bigger than the others, and he did them to wit that they should rest there that night, & bade them sleep in peace and without fear till the morrow. So they entered, and found beds thereon of heather and ling, and they laid them down sweetly, like brother and sister, when they had kissed each other. But they noted that four brisk men lay with out the booth, & across the door, with

their weapons beside them, so that they Malter must needs look upon themselves as bids farewell captives. B Then Walter might not ree frain him. but spake: Sweet and dear friend, I have come a long way from the guav at Langton, and the vision of the Dwarf. the Maid. and the Lady: and for this kiss wherewith I have kissed thee e'en now. & the kindness of thine eves. it was worth the time & the travail. But to/morrow, meseemeth. I shall go no further in this world, though my jour, ney be far longer than from Langton bither. And now may God and All Bal lows keep thee amongst this wild folk. whenas I shall be gone from thee. She laughed low and sweetly. & said: Dear friend, dost thou speak to me thus mournfully to move me to love thee bet ter? Then is thy labour lost; for no bet, ter may I love thee than now I do; and that is with mine whole heart. But keep agood courage. I bid thee: for we benot sundered vet, nor shall we be. Nor do I deem that we shall die here. or to/mor/ row: but many years hence, after we have known all the sweetness of life. Mean, 203

while,Ibid thee good night,fair friend1 Chapter XXVII. Morning amongst the Bears 京都

6 Malter laid him down & fellasleep,&knew no more till he awoke in bright day, light with the Maid stand, ingover him. She was fresh from the water, for she had

been to the river to bathe her, and the sun through the open door fell stream, ing on her feet close to Malter's pillow. he turned about & cast his arm about them.& caressed them.while she stood smiling upon him; then he arose and looked on her, and said: how thou art fair and bright this morning 1 And yet ... and yet... were it not well that thou dooff thee all this faded and drooping bravery of leaves and blossoms, that maketh thee look like to a jongleur's damselonamorrowofMavday? #Hnd he gazed rue fully on her B Shelaughed on him merrily, and said : Yea, & belike these others think no better of my attire.ornotmuch better:for vonder they

are gathering small wood for the burnt, **Walter** offering; which, for sooth, shall be thou **doubteth** and I, unless I better it all by means of the wisdom I learned of the old woman, and perfected betwixt the stripes of my Mistress, whom a little while ago thou loved st somewhat.

ND as she spake her eyes spark-led, her cheek flushed, and her limbs and her feet seemed as if they could scarce refrain from dancing for joy. Then Malter knithis brow, and for a moment a thought half/framed was in his mind. Is it so, that she will bewray me and live without me? and be cast his eyes on to the ground. But she said: Lookup, & intomine eyes, friend. and see if there be in them any falseness toward thee! for I know thy thought: I know thy thought. Dost thou not see thatmy joy and gladness is for the love of thee. & the thought of the rest from trouble that is at hand? IF he looked up. & his eves met the eves of her love. and he would have cast his arms about her: but she drewaback and said: Nav. thou must refrain thee awhile, dear 205

She bearteneth hím friend. lest these folk cast eves on us. and deem us over lover/like for what I am to bid them deem me. Hbide a while. and then shall all bein me according to thy will. But now I must tell thee that it is not very far from noon. and that the Bears are streaming into the Dale. and already there is an host of men at the Doom/ring. &. as I said. the bale for the burnt/offering is well/nigh dight. whether it be for us. or for some other creature. And now I have to bid thee this, and it will be a thing easy for thee to do. to wit, that thou look as if thou wert of the race of the Gods. and not to blench, or show sign of blenching. whatever betide: to yearsay both my yearsay & mynay say: and lastly this. which is the only hard thing for thee (but thou hast already done it before somewhat), to look upon me with no masterful eves of love, nor as if thou wert at once praving me& commanding me: rather thou shalt so demean thee as if thou wert my man all simply, and nowisemy master. BO friend beloved, said Walter, here at least art thou the 206

master, and I will do all thy bidding, in Bere certain hope of this, that either we shall cometh live together or die together. breakfast

acas they spoke, in came the el der, & with him a young maiden, bearing with them their thirden, bearing with them their breakfast of curds and cream and strawberries. and he bade them eat. So they ate, and were not unmerry: and the while of their eating the elder talked with them soberly, but not hardly, or with any seeming enmity: & ever his talk gat on to the drought, which was now burning up the down/pastures: & how the grass in the watered dales, which was no wide spread of land, would not hold out much longer unless the God sent them rain. Hnd Malternoted that those two. the elder and the Maid, eved each other curiously amidst of this talk: the elder intent on what she might say. & if she gave heed to his words; while on her side the Maid answered his speech grav ciously and pleasantly, but said little that was of any import: nor would she have him fix her eyes, which wandered lightly from this thing to that: nor 207

would her lips grow stern and stable, but ever smiled in answer to the light of her eyes, as she sat there with her face as the very face of the gladness of the summer day.

Chapter XXVIII. Of the new God of the Bears 森森

T last the old man said: Mychildren, ye shall now come with me unto the Doom/ring of our folk. the Bears of the Southern Dales, and deliver to them your errand; and I beseech you to have pity upon your own bodies, as I have pity on them; on thine especially, Maiden, sofair and bright a creature as thou art; for so it is, that if ye deal us out light & lying words after the mannerof dastards, yeshallmiss the worship & glory of wending away amidst of the flames, a gift to the God and a hope to the people, and shall be passed by the rods of the folk, until ve faint & fail amongst them, & then shall ye be thrust down into the flow at the Dale's End, & a stone/laden hurdle cast upon The Man, you, that we may thenceforth forget mote yourfolly & The Maid now looked full into his eyes, and Malter deemed that theold man shrank before her; but she said: Thou art old and wise, O great man of the Bears, yet nought I need to learn of thee. Now lead us on our way to the Stead of the Errands.

O the elder brought them along to the Doom/ring at the eastern end of the Dale; and it was now all peopled with those buge men, weaponed after their fashion, and standing up, so that the grey stones thereof but showed a little over their heads. But amidmost of the said Ring was a big stone, fashioned as a chair, whereon sat a very old man, long/boary and white/bearded, & on either side of him stood a great/limbed woman clad in war/gear, holding, each of them, a long spear, and with a flint/bladed knife in the girdle; and there were no other women in all the Mote.

p

They stand before the folk

DEN the elder led those twain into the midst of the Mote, and there bade them go up on to a wide. flat/topped stone. six feet above the ground, just over against the ancient chieftain; and they mounted it by arough stair. & stood there before that folk: Malter in his array of the outward world, which had been fair enough, of crimson cloth and silk, & white linen, but was now travelstained and worn: & the Maid with nought upon her. save the smock wherein she had fled from the Golden House of the Mood bevond the Morld. decked with the faded flowers which she had wreathed about her vesterday. Nevertheless. soit was. that those big men eved her intently. and with somewhat of worship. Caldid Walter, according to her

bidding, sink down on his knees beside her, & drawing his sword, hold it before him, as if to keep all interlopers aloof from the Maid. And there was silence in the Mote, & alleyes were fixed on those twain.

T last the old chief arose and The Maid spake: Ye men, here are come is bidden a man and a woman, we know to speak not whence: whereas they have given word to our folk who first met them. that they would tell their errand to none save the Mote of the Deople: which it was their due to do. if they were minded to risk it. for either they be aliens without an errand hither. save. it may be, to bequile us, in which case they shall presently die an evil death: or they have come amongst us that we may give them to the God with flintredge and fire: or they have a message to us from some folk or other, on the issue of which lieth life or death. Now shall ve hear what they have to say concerning themselves and their faring bither. But, meseemeth, it shall be the woman who is the chief and hath the word in hermouth: for. lo vou! theman kneeleth at her feet, as one who would serve and worship her. Speak out then, woman, and let our warriors hear thee.

p2

She declareth her Godhead

DEN the Maid lifted up hervoice, & spake out clear and shrilling, like to a flute of the best of the minstrels: Ve men of the Children of the Bear. I would ask you a question, and let the chieftain who sitteth before me answer it. @ The old man nodded his head, and she went on: Tell me. Children of the Bear, how long a time is worn since ye saw the God of your worship made manifest in the body of a woman? Said the elder: Many winters have worn since my father's father was a child. & saw the very God in the bodily form of a woman B Then she said again: Did ye rejoice at her coming, and would ye rejoice if once more she came amongst vou? . Vea, said the old chieftain. for she gave us gifts, and learned us lore, and came to us in no terrible shape, but as a young woman as goodly as thou B Then said the Maid: Now, then, is the day of your gladness come; for the old body is dead, & Lam the new body of your God. come amongst you for your welfare Then fell a great silence on the Mote.

till the old man spake and said: What The shall I say and live? for if thou be verily Bears the God, and I threaten thee, wilt thou crave a notdestroyme?Butthouhastspoken token of agreat word with a sweet mouth. & hast her taken the burden of blood on thy lily hands: and if the Children of the Bear be befooled of light liars, how shall they put the shame off them? Therefore I sav. show to us a token: and if thou be the God, this shall be easy to thee; & if thou show it not, then is thy falsehood manifest. & thou shalt dree the weird. for we shall deliver thee into the hands of these women here, who shall thrust thee down into the flow which is hereby, after they have wearied themselves with whipping thee. But thy man that kneeleth at thy feet shall we give to the true God, and he shall go to her by the road of the flint and the fire. hast thou heard? Then give to us the sign and the token.

DEchanged countenance no whit at his word; but her eves were the brighter, and her cheek the

fresher: and her feet moved a little, as

She answereth

if they were growing glad before the dance: & she looked out over the Mote. and spake in her clear voice: Old man. thouneedest not to fear for thy words. forsoothitisnotmewhomthouthreat, enest with stripes and a foul death. but some light fool and liar, who is not here. Now hearken 1 I wot well that ve would have somewhat of me. to wit. that I should send you rain to end this drought, which otherwise seemeth like to lie long upon you: but this rain, I must go into the mountains of the south to fetch it you: therefore shall certain of your warriors bring me on my way, with this my man. up to the great pass of the said mountains, and we shall set out thitherward this very day She was silent a while. & all look, ed on her. but none spake or moved, so that they seemed as images of stoneamongst the stones. Then shespake again and said: Some would say, men of the Bear, that this were a sign and a token great enough; but I know you, and how stubborn & perverse of heart ve be: and how that the gift not yet 214

within your hand is no gift to you; and Now is the wonder vesee not, your hearts trow the token not. Thereforelook yeupon meas here made Istand, Iwho have come from the fair, manifest er country and the green/wood of the lands. and see if I bear not the summer with me, and the heart that maketh increase and the hand that giveth.

O then 1 as she spake, the faded flowers that hung about her gathered life and grew fresh again: the woodbine round her neck & her sleek shoulders knit itself togeth, er and embraced her freshly, and cast its scent about her face. The lilies that airded her loins lifted up their heads. and the gold of their tassels fell upon her: the evebright grew clean blue again upon her smock: the eglantine found its blooms again, and then began to shed the leaves thereof upon her feet: the meadow/sweet wreathed amongst it made clear the sweetness of her leas. & the mouse lear studded her raiment as with gems. There she stood amidst of the blossoms, like a great orient pearl against the fretwork

Glad are the Bears

of the goldsmiths, and the breeze that came up the valley from behind bore the sweetness of her fragrance allover the Man/mote.

DEN, indeed, the Bears stood up, and shouted and cried, and smote on their shields, & toss/ ed their spears aloft. Then the elder rose from his seat. & came up humbly to where she stood, and praved her to sav what she would have done: while the others drew about in knots. but durst not come very nigh to her. She answered the ancient chief. and said. that she would depart presently toward the mountains, whereby she might send them the rain which they lacked. and that thence she would away to the southward for a while: but that they should hear of her, or, it might be, see her, before they who were now of middleage should be gone to their fathers Ethen theold man besought her that they might make ber a litter of fragrant green boughs, and so bear her away toward the mountain pass amidst a triumph of the whole folk. But she leapt

lightly down from the stone, and walk, They ed to and fro on the greensward, while it seemed of her that her feet scarce touched the grass: & she spake to the ancient chief where he still kneeled in worship of her. & said: Nav: deemest thou of me that I need bearing by men's hands. or that I shall tire at all when I am doing my will, and I. the very heart of the year's increase? So it is. that the aoing of my feet over your pastures shall make them to thrive, both this year and the coming years: surely will I go afoot.

O they worshipped her the more, and blessed her; and then first of all they brought meat, the daintiest they might, both for her and for Malter. But they would not look on the Maid whiles she ate. or suffer Malter to behold her the while. Afterwards. when they had eaten. some twenty men. weaponed after their fashion. made them ready to wend with the Maiden up into the mountains, and anon they set out thitherward all together. howbeit. the hugemen held them ever somewhat

217

give the God to eat

aloof from the Maid; & when they came to the resting/place for that night, where was no house, for it was up amongst the foot/hills before the moun/ tains, then it was a wonder to see how carefully they built up a sleeping/place for her, & tilted it over with their skincloaks, and how they watched nightlong about her. But Walter they let sleep peacefully on the grass, a little way aloof from the watchers round the Maid.

Chapter XXIX. Malter strays in the Dass & is sundered from the Maid &

ORNING came, & they arose and went on their ways, and went all day till the sun was nigh set, and they were come up into the very pass; & in

the jaws thereof was an earthen howe. There the Maid bade them stay, & she went up on to the howe, & stood there and spake to them, and said: O men of the Bear, I give you thanks for your following, and I bless you, and promise

vou the increase of the earth. But now The Maid ve shall turn aback, and leave me to go my ways: and my man with the iron sword shall follow me. Now, maybe, I shall come amongst the Bear, folk again before long, and yet again, & learn them wisdom : but for this time it is en, ough. And I shall tell you that ve were best to hasten home straightway to vour houses in the down land dales. for the weather which I have bidden for vou is even now coming forth from the forge of storms in the heart of the mountains. Now this last word I give you, that times are changed since I wore the last shape of God that ve have seen. wherefore a change I command you. If so be aliens come amongst you, I will not that ve send them to me by the flint & the fire ; rather, unless they be baleful unto you, & worthy of an evil death. ve shall suffer them to abide with you: ve shall make them become children of the Bears, if they be goodly enough & worthy, & they shall be my children as ye be; otherwise, if they be ill favoured and weakling, let them live & be thralls 219

command, eth & for biddeth

Walter & the Maid are sundered to you, but not join with you, man to woman. Now depart ye with my blessing.

OUSOEVER, it was now twi light or more, &, for all his haste, dark night overtook him, so that perforce he was stayed amidst the tan gle of the mountain ways. And, more over, ere the night was grown old, the weather came upon him on the back of a great south wind, so that the mountain nooks rattled and roared, & there was the rain & the bail, with thunder and

lightning.monstrous and terrible. and Malter is all the huge array of a summer storm. troubled So he was driven at last to crouch under a big rock and abide the day.

at not so were his troubles at an end. for under the said rock be fell asleep, and when he a-

woke it was day indeed: but as to the pass. the way thereby was blind with the driving rain and the lowering lift: so that, though he struggled as well as he might against the storm & the tan, gle, he made but little way.

ND now once more the thought came on him, that the Maid was of the fays, or of some race even mightier: and it came on him now not as erst, with half fear and whole desire. but with a bitter oppression of dread. of loss and misery: so that he began to fear that she had but won his love to leave him and forget him for a new, comer, after the wont of fav/women.as old tales tell.

avs he battled thus with storm & blindness, & wanhope of his life: for he was growing

he finds rest

weak & fordone. But the third morning the storm abated. though the rain yet fell heavily, and he could see his way somewhat as well as feel it: withal be found that now his path was leading him downwards. As it grew dusk, he came down into a grassy valley with a streamrunningthroughittothesouth ward, and the rain was now but little. coming down but in dashes from time to time. So he crept down to the stream, side. & lav amongst the bushes there: & said to himself, that on the morrow he would get him victual, so that he might live to seek his Maiden through the wide world. He was of somewhat better heart: but now that he was laid quiet. & had no more for that present to trouble him about the way. the anauish of his loss fell upon him the keener, and he might not refrain him from lamenting his dear Maiden aloud. as one who deemed himself in the empi ty wilderness: & thus he lamented for her sweetness and her loveliness, and the kindness of her voice & her speech, & her mirth. Then he fell to crving out 222

concerning the beauty of her shaping. praising the parts of her body, as her face, and her hands, and her shoulders, and her feet, and cursing the evil fate which had sundered him from the friendliness of her. and the peerless fashion of her.

Mornína in the dale

ChapterXXX. Now they meet again a

OMPLHINING thuswise. he fell asleep from sheer weariness. & when he awoke it was broad day, calm and bright and cloudless, with the scent

of the earth refreshed going up into the heavens, and the birds singing sweetly in the bushes about him: for the dale whereunto he was now come was a fair and lovely place amidst the shelving slopes of the mountains, a paradise of the wilderness, and nought but pleasant and sweet things were to be seen there, now that the morn was so clear and sunny.

Ce arose and looked about him. & saw where, a hundred vards aloof. was a thicket of small wood. as

Now they meet agaín

thorn & elder & whitebeam. all wreath, ed about with the bines of wayfaring tree: it hid a bight of the stream, which turned round about it, and betwixt it and Malter was the grass short and thick.and sweet. & all beset with flow, ers: and be said to himself that it was even such a place as wherein the angels were leading the Blessed in the great painted paradise in the choir of the big church at Langton on Bolm. But lo1 as he looked he cried aloud for joy. for forth from the thicket on to the flowerv grass came one like to an angel from out of the said picture, white/clad and bares foot. sweet of flesh. with bright eves and ruddy cheeks; for it was the Maid herself. So he ran to her, and she abode him, holding forth kind hands to him. and smiling, while she wept for iov of the meeting. he threw himself upon her, and spared not to kiss her. her cheeks and her mouth. & her arms and her shoulders. & wheresoever she would suffer it. Till at last she drew aback a little, laughing on him for love, and said: forbear now, friend, for it is 224

enough for this time, and tell me how here is thou hast sped @ Ill, ill, said he, @ breakfast What ails thee? she said B hunger. he said, and longing for thee. 1 Tell. she said. me thou hast : there is one ill quenched: take my hand. & we will see to the other one BSo he took her hand. and to hold it seemed to him sweet ber vond measure. But he looked up, and saw a little blue smoke going up into the air from beyond the thicket: and he laughed. for he was weak with hunger. & he said: Tho is at the cooking vonder? B Thou shalt see. she said: and led him therewith into the said thicket & through it, and lo 1 a fair little grassy place.full of flowers.betwixt the bush, es and the bight of the stream : and on the little sandy ere. just off the green sward, was a fire of sticks. & beside it two trouts lying, fat and red/flecked, B Bere is the breakfast, said she: when it was time to wash the night off me e'en now. I went down the strand here into the rippling shallow. & saw the bank below it, where the water draws together vonder. & deepens, that it seemed 225 a

him that last night

Sheheard like to hold fish; and, whereas I looked to meet thee presently. I groped the bank for them, going softly: and lo

> thou 1 helpme now, that we cook them. Othey roasted them on the red embers.and fell to and ate well, both of them, and drank of the water of the stream out of each other's bollow bands: and that feast seemed glorious to them, such gladness went with it.

> at when they were done with their meat. Malter said to the Maid: J And how didst thou know that thou shouldst see me presently? @ She said, looking on him wistfully: This needed no wizardry. I lay not so far from thee last night. but that I heard thy voice and knew it Said he. Thy didst thou not come tome then, since thou heardest me ber moaning thee? B She cast her eves down, and plucked at the flowers and grass, and said: It was dear to hear thee praising me; I knew not before that I was so sore desired. or that thou hadst taken such note of my body. & 226

found it sodear, Chen shereddened She tells sorely, and said: I knew not that aught of her of me had such beauty as thou didst fear bewail P And she wept for joy. Then she looked on him and smiled, & said: Wilt thou have the very truth of it? I went close up to thee, and stood there hidden by the bushes and the night. And amidst thy bewailing, I knew that thou wouldst soon fall asleep, and in sooth I out/waked thee.

DEN was she silent again; and he spakenot, but looked on her shyly; and she said, reddening yet more: furthermore, I must needs tell thee that I feared to go to thee in the dark night, and my beart so yearn, ing towards thee, #And she hung her head adown; but he said: Is it so indeed, that thou fearest me? Then doth that make me afraid... afraid of thy nay, say. for I was going to entreat thee, & say to thee: Beloved, we have now gone through many troubles; let us now take a good reward at once, & wed together, here amidst this sweet and pleasant house of the mountains,

q 2

She ere we go further on our way; if indeed would live we go further at all. for where shall we amidst folk find any place sweeter or happier than this?

> at she sprang up to her feet, and stood there trembling before him, because of her love: and she said: Beloved. I have deemed that it were good for us to go seek man, kind as they live in the world. and to live amongst them. And as for me. I will tell thee the sooth, to wit, that I long for this sorely. for I feel afraid in the wilderness, and as if I needed help and protection against my Mistress, though she be dead; and I need the comfort of many people, and the throngs of the cities. I cannot forget her: it was but last night that I dreamed (Isuppose as the dawn grew arcold) that I was vet under her hand. and she was stripping me for the torment: so that I woke up panting and crving out. I pray thee be not angry with me for telling thee of my desires; for if thou would stnot have it so. then bere will I abide with thee as thy mate.

and strive to gather courage.

E rose up and kissed her face, feareth & said: Nay, I had in sooth no the city Mind to abide here for ever; I meant but that we should feast a while here, and then depart: sooth it is, that if thou dreadest the wilderness, somer what I dread the city I She turned pale. & said: Thou shalt have the will. my friend. if it must be so. But bethink theel we be not vet at our journev's end, and may have many things and much strife to endure. before we be at peace and in welfare. Now shall I tell thee ... did I not before? ... that while I am a maid untouched. my wis, dom, and somedeal of might, abideth with me, and only so long. Therefore I entreat thee, let us go now, side by side, out of this fair valley, even as we are, so that my wisdom and might may help thee at need. for, my friend, I would not that our lives be short, so much of joy as hath now come into them D Yea, beloved, he said, let us on straightway then, and shorten the while that sundereth us, & Love, she

229

he

They said, thou shalt pardon me one time leave that for all. But this is to be said, that I dale know somewhat of the haps that lie a little way ahead of us: partly by my

lore, and partly by what I learned of this land of the wild folk whiles thou wert lying asleep that morning.

by the water, and came into the open valley, and went their ways through the pass; and it soon became stony again. as they mounted the bent which went up from out the dale. And when they came to the brow of the said bent, they had a sight of the open country lying fair and joyous in the sunshine, & amidst of it. against the blue hills, the walls and towers of a great city E Then said the Maid: O. dear friend. lo vou! is not that our abode that lieth vonder.and is so beauteous? Dwell not our friends there, and our protection against uncouth wights, and mere evil things in guileful shapes? O city, I bid thee hail 1 But Malter looked on her, and smiled somewhat: and said: I rejoice in thy

iov. But there be evil things in vonder Of the city also, though they be not favs nor city which devils. or it is like to no city that I wot of. And in every city shall foes grow aloof up to us without rhyme or reason, and life therein shall be tangled unto us @Vea.she said: but in the wilderness amongst the devils, what was to be done by manly might or valiancy? There hadst thou to fall back upon the quile and wizardry which I had filched from my very foes. But when we come down vonder, then shall thy valiancy prevail to cleave the tangle for us. Or at the least.it shall leave a tale of thee behind. & I shall worship thee. B he laughed. and his face grew brighter: Mastery mows the meadow, quoth he, and one man is of little might against many. But I promise thee I shall not be sloth, ful before thee.

they see

Chapter XXXI. They come upon new folk 政政

ITH that they went down from the bent again, and came to where the pass narrowed so much, that they went betwixt a steep wall of

rock on either side: but after an hour's going, the said wall gave back suddenly, and, or they were ware almost, they came on another dale like to that which they had left, but not so fair, though it was grassy and well watered, & not so big either. But here indeed befell a change to them; for lo1 tents and pavilions pitched in the said valley, and amidst of it a throng of men, mostly weaponed, and with horses ready sad, dled at hand. So they stayed their feet, & Malter's heart failed him, for he said to himself: Tho wotteth what these men may be, save that they be aliens? It is most like that we shall be taken as thralls: and then, at the best, we shall be sundered: & that is all one with the

worst.

SABUT the Maid, when she saw the come borses. & the gav tents, and the bennons fluttering. & the glitter of spears, and gleaming of white armour. smote her palms together for iov. and cried out: here now are come the folk of the city for our welcoming, and fair and lovely are they, & of many things shall they be thinking, Lamany things shall they do, and we shall be partakers thereof. Come then, and let us meet them. fair friend ! But Maltersaid: Alasithou knowest not: would that we might flee! But now is it over late: so put we a good face on it, and go to them quietly, as erewhile we did in the Bear/country.

O did they; and there sundered six from the men/at/arms and r came to those twain, and made humble obeisance to Walter, but spake no word. Then they made as they would lead them to the others, and the twain went with them wondering, and came into the ring of men/at/arms, & stood before an old boar knight, armed all,

233

They come amongst those men

They are borne away

save his head, with most goodly armour, and he also bowed before Malter.butspakenoword. Then they took them to the master pavilion, and made signs to them to sit, and they brought them dainty meat and good wine. And the while of their eating arose up a stir about them; and when they were done with their meat. the ancient knight came to them.still bowing in courteous wise, and did them to wit by signs that they should depart: & when they were with, out.they sawall the other tents struck. and men beginning to busy them with striking the pavilion, and the others mounted and ranked in good order for the road: & there were two horse litters before them, wherein they were bidden to mount. Malter in one. and the Maid in the other, and no otherwise might they do. Then presently was a horn blown, & all took to the road together: and Walter saw betwixt the curtains of the litter that mensatiarms rode on either side of him. albeit they had left him his sword by his side.

Othey went down the mountain, The Gate passes, and before sunset were of a City gotten into the plain; but they made no stav for night, fall, save to eat a morsel and drink a draught, going through the night as men who knew their way well. As they went. Malter wony dered what would betide. and if peradventure they also would be for offering them up to their Gods: whereas they werealiens for certain. & belike also Sar racens. Moreover there was a cold fear at his heart that he should be sundered from the Maid. whereas their masters now were mighty men of war, holding in their hands that which all men desire. to wit. the manifest beauty of a woman. Vet hestrove to think the best ofit that he might. And so at last, when the night was far spent, and dawn was at hand, they stayed at a great & mighty gate in a huge wall. There they blew loudly on the horn thrice, & thereafter the gates were opened. & the vall passed through into a street, which seemed to Malter in the glimmer to be both great & goodly amongst the abodes of men.

A palace Then it was but a little ere they came into a square, wide spreading, one side whereof Malter took to be the front of amost goodly house. There the doors of the court opened to them or ever the born might blow, though, forsooth. blow it did loudly three times; all they entered therein, and men came to Malterand signed to him to alight. Sodid he. & would have tarried to look about for the Maid, but they suffered it not. but led him up a huge stair into a chamber, very great, and but dimly lighted because of its greatness. Then they brought him to a bed dight as fair as might be, & made signs to him to strip and lie therein. Derforce he did so. and then they bore away his raiment, & left him lying there. So he lay there quietly. deeming it no avail for him. a mothernaked man, to seek escape thence; but it was long ere hemight sleep, because of his trouble of mind. Ht last, pure weariness got the better of his hopes and fears, and he fell into slumber just as the dawn was passing into day.

bapter XXXII. Of the new King of the City and Land of Stark wall of DEN be awoke again the sun was shining brightly into that chamber, and be looked, and beheld that it was peerless of beauty & riches, amongst all that

he had ever seen: the ceiling done with gold and over/sea blue: the walls hung with arras of the fairest, though he might not tell what was the history done therein. The chairs and stools were of carven work well be painted. & amídmost was a great ívory chair under a cloth of estate. of bawdekin of gold and green, much berpearled: & all the floor was of fine work alexandrine. Elooked on all this, wondering what had befallen him, when lot there came folk into the chamber, to wit, two serving/men well/bedight, and three old men clad in rich gowns of silk. These came to him and (still by signs, without speech) bade him arise and come with them : and when he

Malter is taken to the bath

bade them look toit that he was naked. and laughed doubtfully, they neither laughed in answer, noroffered him anv raiment, but still would have him arise, and he did so perforce. They brought him with them out of the chamber, and through certain passages pillared and goodly, till they came to a bath as fair as any might be: and there the serving, men washed him carefully & tenderly. theold men looking on the while. Then it was done. still they offered not to clothe him, but led him out, & through the passages again, back to the chamber. Only this time he must pass between a double hedge of men, some weaponed, some in peaceful array, but all clad gloriously, & full chieftain/like of aspect, either for valiancy or wisdom N the chamber itself was now a concourse of men, of great esat tate by deeming of their array; but all these were standing orderly in a ring about the ivory chair aforesaid. Now said Malter to himself: Surely all this looks toward the knife and the altar for me; but he kept a stout coun, 238

tenance despite of all.

O they led him up to the ivory raiments chair, & he beheld on either side thereof a bench, & on each was laidaset of raiment from the shirt upwards: but there was much diversity betwixt these arrays. for one was all of robes of peace, glorious & begemmed. unmeet for any save a great king : while the other was war/weed, seemly, wellfashioned. but little adorned: nav rather. worn and bestained with weather. and the pelting of the spear storm.

Sou those old men signed to Malter to take which of those raiments he would, and do it on. he looked to the right and the left, and when he had looked on the war/gear. the heart arose in him, and he called to mind the array of the Goldings in the forefront of battle, and he made one step toward the weapons, and laid his hand thereon. Then ran a glad murmur through that concourse, and the old men drewup to him smiling & joyous. and helped him to do them on ; & as he took up the helm, he noted that over its 230

The two

Walter takeththe war/gear broad brown iron sat a golden crown. O when he was clad & weaponed, girt with a sword, & a steel axe in his hand, the elders showed him to the ivory throne, and he laid the axe on the arm of the chair, and drew forth the sword from the scabbard, and sat him down, and laid the ancient blade a, cross his knees; then he looked about on those great men, & spake: How long shall we speak no word to each other, or is it so that God hath stricken you dumb?

DEN all they cried out with one voice: All hail to the King, the King of Battle! Spake Walter: If I be king, will ye do my will as I bid you? Hnswered the elder: Nought have we will to do, lord, save as thou biddest Said Walter: Thou then, wilt thou answer a question in all truth? Yea, lord, said the elder, if I may live af, terward F Then said Walter: The wo, man that came with me into your Camp of the Mountain, what hath befallen her? The elder answered: Nought hath befallen her, either of good or evil,

save that she hath slept and eaten and The King bathed her. Ahat, then, is the King's command, pleasure concerning her? I That ye eth con bring her hither to me straightway, cerning said Malter Fyea, said the elder; & in the Maid what guise shall we bring her hither? shall she be arraved as a servant. or a great lady? B Then Malter pondered awhile, and spake at last: Ask her what is her will herein, and as she will have it. so let it be. But set ve another chair beside mine. & lead her thereto. Thou wise old man. send one or two to bring her in hither, but abide thou, for I have a question or two to ask of thee yet. And ye, lords, abide here the coming of my sherfellow, if it weary you not. O the elder spake to three of the

most honourable of the lords, & they went their ways to bring in the Maid.

241

r

Chapter XXXIII. Concerning the fashion of King, making in Stark, wall

EANMBILE the King spake to the elder, & said: Now tell me where of Lam become king, and what is the fashion and cause of the king making; for won

drous it is to me, whereas I am but an alien amidst of mighty men JE Lord, said the old man. thou art become king of a mighty city, which hath under it many other cities and wide lands, and havens by the searside, and which lack, eth no wealth which men desire. Many wise men dwell therein, and of fools not more than in other lands. H valiant bost shall follow thee to battle when needs must thou wend afield; an host not to be withstood, save by the ancient God/folk, if any of them were left upon the earth, as belike none are. And as to the name of our said city, it hight the City of the Stark / wall, or more shortly, Stark/wall. Now as to the fashion of our king, making: If our king

dieth & leaveth an heir male, begotten Theproof of his body, then is he king after him: of a true but if he die & leave no heir, then send kingwe out a great lord, with knights and sending sergeants, to that pass of the mountain whereto ve came vesterday: & the first man that cometh unto them, they take & lead to the city, as they did with thee, lord. for we believe and trow that of old time our forefathers came down from the mountains by that same pass. poor and rude, but full of valiancy, ber fore they conquered these lands, and builded the Stark/wall. But now furthermore, when we have gotten the said wanderer. & brought him home to our city, we behold him mother/naked, all the great men of us, both sages & war, riors: then if we find him ill fashioned and counterfeit of his body, we roll him in a great carpet till be dies: or whiles. if he be but a simple man, and without quile, we deliver him for thrall to some artificer amongst us, as a shoemaker, a wright, or what not, & so forget him. But in either case we make as if no such man had come to us, and we send again

r 2

The proof the lord and his knights to watch the again

pass; for we say that such an one the fathers of old time have not sent us. Butagain.when we have seen to the new, comer that he is well fashioned of his body. all is not done: for we deem that never would the fathers send us a dolt or a craven to be our king. Therefore we bid the naked one take to him which he will of these raiments. either the ancient armour, which now thou bearest, lord. or this golden raiment here: and if he take the war/gear, as thou takedst it. King, it is well; but if he take the rai ment of peace, then hath he the choice either to be thrall of some good man of the city. or to be proven how wise he may be. & so fare the narrow edge betwixt death and kingship; for if he fall short of his wisdom, then shall be die the death. Thus is thy question answered. King, and praise be to the fathers that they have sent us one whom none may doubt, either for wisdom or valiancy.

Chapter XXXIV. Now cometh the Maid to the King 🕸 🕸

DEN all they bowed before the King, & hespake again: What is that noise that I hear without, as if it were the rising of the sea on a sandy shore, when the

south/west wind is blowing? & Then the elder opened his mouth to answer: but before he might get out the word. there was a stir without the chamber door, and the throng parted, and lol amidst of them came the Maid, & she yet clad in nought save the white coat wherewith she had won through the wilderness, save that on her head was a garland of red roses, and her middle was wreathed with the same. fresh & fair she was as the dawn of June: her face bright, red/lipped, and clear/eyed, and her cheeks flushed with hope and love. She went straight to Walter where he sat, and lightly put away with her hand the elder who would lead her to the ivory throne beside the King: but

in the Queen's seat

She is set she knelt down before him. & laid her hand on his steel/clad knee, and said: Omv lord.now I see that thou hast ber guiled me, and that thou wert all along a king/born man coming home to thy realm. But so dear thou hast been to me: and so fair and clear, and so kind withal do thine eves shine on me from under the grey war, belm, that I will ber seech thee not to cast me out utterly, but suffer me to be thy servant & hand, maid for a while. Milt thou not?

Wat the King stooped down to 8 her and raised her up, & stood on his feet, and took her hands and kissed them, and set her down ber side him, and said to her: Sweetheart. this is now thy place till the night com eth.even by my side BSo she sat down there meek and valiant, her hands laid in her lap. & her feet one over the other: while the King said: Lords, this is my beloved. & my spouse. Now, there, fore.if ve will have me for King. ve must worship this one for Queen and Lady; or else suffer us both to go our wavs in peace.

BEN all they that were in the Hll those chamber cried out aloud : The love the Queen, the Lady | The beloved Maid of our lord ! BAndthis cry came from their hearts, & not their lips only: for as they looked on her, and the brightness of her beauty, they saw also the meekness of her demeanour, and the high heart of her, & they all fell to loving her. But the young men of them, theircheeksflushed as they beheld her. and their hearts went out to her. & thev drew their swords & brandished them aloft. & cried out for her as men made suddenly drunk with love: The Queen. the Lady, the lovely one!

Chapter XXXV. Of the King of Stark, wall and his Queen 2 4

at while this betid. that murmur without, which is a foresaid, grew louder: & it smote on the King's ear, and he said again to the elder: Tell us now of

at noise withoutward, what is it? 🖉 Said the elder: If thou, King, and the Queen, wilt but arise and stand in the

Now they window, and go forth into the hanging look on gallery thereof, then shall ye know at the throng once what is this rumour, and thereof the folk withal shall ye see a sight meet to rejoice the heart of a king new come into kingship.

O the Kingarose & took the Maid by the hand, & went to the window and looked forth: and loi the great square of the place all thronged with folk as thick as they could stand. and the more part of the carles with a weapon in hand, and many armed right gallantly. Then he went out into the gallery with his Queen still holding her hand, and his lords & wise men stood behind him. Straightway then arose a cry, and a shout of joy & welcome that rent the very heavens. & the great place was all glittering and strange with the tossing up of spears & the brandishing of swords, & the stretching forth of bands.

and here is warding and protection a-248

rainst the foes of our life and soul. O The talk blessed be thou & thy valiant heart 1. of two But Malter spake nothing, but stood neighas one in a dream : & vet. if that might bours be, his longing toward her increased manifold.

anidst of the throng, stood two neighbours somewhat anigh to the window; and quoth one to the other: See thou! the new man in the ancient armour of the Battle of the Maters, bearing the sword that slew the foeman king on the Davof the Doubtful Onset! Sure, ly this is a sign of good/luck to us all Vea, said the second, he beareth his armour well, and the eves are bright in the head of him: but hast thou beheld well his sherfellow, and what the like of her is? @ I see her. said the other. that she is a fair woman; vet somewhat worse clad than simply. She is in her smock. man. and were it not for the balusters I deem ve should see her barefoot. That is amiss with her? BOost thounot see her, said the second neight bour. that she is not only a fair woman.

The King & Queen arraved anew

but yet more, one of those lovely ones that draw the heart out of a man's body, one may scarce say for why? Surely Stark/wall hath cast a lucky net this time. And as to her raiment. I see of ber that she is clad in white & wreathed with roses, but that the flesh of her is so wholly pure & sweet that it maketh all her attire but a part of her body, and halloweth it. so that it hath the semblanceofgems. Hlas, my friend 1 letus hope that this Queen will fare abroad unseldom amongst the people.

has, then, they spake; but after a while the King & his mate went back into the chamber, & he gave

command that the women of the Queen should come and fetch her away, to at, tire her in royalarray. And thither came the fairest of the honourable damsels. &were fain of being her waiting women. Therewithal the King was unarmed, & dightmost gloriously, but still he bore the Sword of the King's Slaying: and sithence were the King and the Queen brought into the great hall of the palace, and they met on the dais. & kissed

before the lords and other folk that They ride thronged the hall. There they ateamor- to the sel and drank a cup together, while all church beheld them: & then were they brought forth, & a white horse of the goodliest. wellbedight, brought for each of them. and thereon they mounted, and went their ways together, by the lane which the huge throng made for them, to the great church, for the hallowing and the crowning: & they were led by one squire alone, and he unarmed: for such was the custom of Stark/wall when a new king should be hallowed: so came they to the great church (for that folk was not miscreant, so to say), and they en, tered it. they two alone, and went into the choir: & when they had stood there alittlewhilewondering at their lot, they heard how the bells fellaringing tunefully over their heads: and then drew near the sound of many trumpets blow, ing together, and thereafter the voices of many folk singing; and then were the great doors thrown open, and the bishop and his priests came into the church with singing and minstrelsy,

The Anointing of the King and thereafter came the whole throng of the folk, and presently the nave of the church was filled by it. as when the water follows the cutting of the dam. and fills up the dyke. Thereafter came the bishop & his mates into the choir. and came up to the King, and gave him and the Queen the kiss of peace. Then was mass sung gloriously : and thereafter was the King anointed & crowned, & great iov was made throughout the church. Afterwards they went back afoot to the palace. they two alone together, with none but the esquire going before to show them the way. And as they went, they passed close beside those two neighbours, whose talk has been told of afore. and the first one. he who had praised the King's war/array. spakeand said: Truly.neighbour.thou art in the right of it: & now the Queen has been dight duly, and hath a crown on ber bead, and is clad in white samite done all over with pearls. I see her to be of exceeding good liness; as goodly, maybe, as the Lord King BQuoth the other: Antomesheseemethasshedid

e'en now: she is clad in white, as then Those she was, and it is by reason of the pure two neight and sweet flesh of her that the pearls bours agaín shine out and glow, & by the holiness of her body is her rich attire hallowed: but, forsooth, it seemed to me as she went past as though paradise had come anigh to our city, and that all the air breathed of it. Solsav. praise be to God and his Ballows who hath suffered her to dwell amongst us ! Baid the first man: forsooth, it is well: but knowest thou at all whence she cometh, and of what lineage she may be? B Nay, said the other. I wot not whence she is: but this I wot full surely, that when she goeth away, they whom she leadeth with her shall be well bestead. Again. of her lineage nought know I: but this I know, that they that come of her, to the twentieth generation, shall bless and praise the memory of her, & hallow her name little less than they hallow the name of the Mother of God.

Ospakethosetwo; but the King and Queen came back to the palace, & satamong the lords and

at the banquet which was held thereafter, and long was the time of their glory, till the night was far spent and all men must seek to their beds.

Chapter XXXVI. Of Malter and the Maid in the days of the Kingship A.

SONG it was, indeed, till the women, by the King's command, had brought the Maid to the King's chamber; and he met her, wars & took her by the shoul-

ders and kissed ber. and said: Hrt thou not weary. sweetheart? Doth not the city, and the thronging folk, and the watching eves of the great ones...doth it not all lie heavy on thee, as it doth upon me? # She said: And where is thecitynow? is not this the wilderness again, and thou and I alone together therein? Begazed at hereagerly, and she reddened. so that her eves shone light amidst the darkness of the flush of her cheeks A he spake trembling and softly, and said: Is it not in one matter better than the wilderness? is not the fear gone, yea, every whit there, The Maid of? @The dark flush had left her face, ungirdeth & she looked on him exceeding sweet- herself lv. and spoke steadily & clearly: Even so it is. beloved. Therewith she set her hand to the girdle that girt her loins, and did it off, and held it out toward him. and said: Bere is the token: this is a maid's girdle, and the woman is un, airt. Sobetook the girdle & ber hand withal. & cast his arms about her: and amidst the sweetness of their love and their safety. & assured hope of many days of joy, they spake together of the hours when they fared the razor/edge betwixt guile & misery and death, and the sweeter vetit grew to them because of it; and many things she told him ere the dawn, of the evil days bygone, and the dealings of the Mistress with her.till the grey day stole into the cham, ber to make manifest her loveliness: which, forsooth, was better even than the deeming of that man amidst the throng whose heart had been so drawn towards her. So they rejoiced together in the new day.

The King dealeth with his councillors

BUT when the fullday was, & Mal ter arose, he called his thanes & wise men to the council: & first he bade open the prison/doors. & feed the needy and clothe them, and make good cheer to all men, high and low. rich & unrich; and thereafter he took counsel with them on many matters, and they marvelled at his wisdom and thekeenness of his wit; and so it was. that some were but half pleased there, at, whereas they saw that their will was like to give way before his in all matters. But the wiser of them rejoiced in him, and looked for good days while bis life lasted.

Oul of the deeds that he did, & his joys and his griefs, the tale shall tell no more; nor of how he saw Langton again, and his dealings there In Stark/wall he dwelt, and reigned a King, well beloved of his folk, sorely feared of their foemen. Strife he had to deal with, at home and abroad; but therein he was not quelled, till he fell asleep fair and softly, when this world had no more of deeds

for him to do. Nor may it be said that Of the the needy lamented him; for no needy King's had he left in his own land. And few good foes he left behind to hate him.

S to the Maid, she so waxed in loveliness and kindness, that it was a year's joy for any to have

cast eves upon her in street or on field. All wizardry left her since the day of her wedding: vet of wit and wisdom she had enough left, and to spare: for she needed no going about. & no guile. any more than hard commands, to have her will done. So loved she was by all folk. forsooth. that it was a mere joy for any to go about her errands. To be short, she was the land's increase. and the city's safeguard, and the bliss of the folk.

OMEMBHT, as the days passed, it misgave her that she had beguiled the Bear/folk to deem her their God: & she considered and thought how she might atone it. So the second year after they had come to Stark/wall, she went with certain folk to the head of the pass that 8 257

endina

led down to the Bears; and there she The stayed the meniatiarms, and went on Queen further with a two score of husbandgoes to visit the men whom she had redeemed from Bears thralldom in Stark/wall: & when they were hard on the dales of the Bears. she left them there in a certain little dale, with their wains and horses, and seed/corn, & iron tools, & went down all birdralone to the dwelling of those huge men, unguarded now by sorcerv. and trusting in nought but her loveliness and kindness. Clad she was now, as when she fled from the mood bevond the Morld. in a short white coat alone, with bare feet and naked arms: but the said coat was now embroidered with the imagery of blossoms in silk and gold, and gems, whereas now her wizardry had departed from her. @So she came to the Bears, and they knew her at once, and worshipped and blessed her, and feared her. But she told them that she had a gift for them, and was come to give it; and therewith she told them of the art of tillage. and bade them learn it: & when they asked 258

her how they should do so, she told her gift them of the men who were abiding to them them in the mountain dale, and bade the Bears take them for their brothers and sons of the ancient fathers, and then they should be taught of them. This they behight her to do, and so she led them to where her freedmen lay, whom the Bears received with all joy and loving/kindness, & took them into their folk So they went back to their dales together; but the Maid went her ways back to her men/atarms and the city of Stark/wall.

DEREAFTER she sent more gifts & messages to the Bears, but never again went herself to see them; for as good a face as she put on it that last time, yet her heart waxed cold with fear, and it almost seemed to her that her Mistress was alive again, and that she was escaping from her & plotting against her once more. S for the Bears, they throve and multiplied; till at last strife arose great & grim betwixt them & other peoples; for they had become

Mhat betid to the Bears sithence mighty in battle: yea, once & again they met the bost of Stark/wall in fight, & overthrew and were overthrown. But that was a long while after the Maid had passed away.

More to be told, saving that they begat between them goodly sons and fair daughters; whereof came a great lineage in Stark/wall; which line/ age was so strong, & endured so long a while, that by then it had died out, folk had clean forgotten their ancient custom of king/making; so that after Walter of Langton there was neveran/ other king that came down to them poor & lonely from out of the Mountains of the Bears.

BERE ends the tale of the Mood beyond the Morld, made by Milliam Morris, and printed by him at the Kelmscott Press, Upper Mall, Bammersmith. finished the 30th day of May, 1894.

Sold by Milliam Morris, at the Kelmscott Press.